D1128773

IMAGES
*of America*

# HUNTINGTON

**ON THE COVER:** Against a backdrop of the patriotic slogans "United We Stand" and "Don't Let Him Down," referring to servicemen, Mayor Roy Howell stands with his staff in 1943. Howell served as mayor from 1942 to 1952 and then again from 1956 to 1958. Howell oversaw Huntington's centennial celebration in 1948 and played a role in bringing the Indiana National Guard to Huntington, presenting the land on which the Armory, completed in 1954, now stands. (Courtesy of the Huntington County Historical Museum.)

IMAGES
*of America*

# HUNTINGTON

Todd Martin and Jeffrey Webb

ARCADIA
PUBLISHING

Published by Arcadia Publishing
Charleston, South Carolina

Printed in the United States of America

Library of Congress Control Number: 2013955787

For all general information, please contact Arcadia Publishing:
Telephone 843-853-2070
Fax 843-853-0044
E-mail sales@arcadiapublishing.com
For customer service and orders:
Toll-Free 1-888-313-2665

Visit us on the Internet at www.arcadiapublishing.com

In Memory of Jack P. Barlow Sr.
Historian, Mentor, and Friend

# CONTENTS

Acknowledgments                                              6

Introduction                                                7

1.    The Founding Era                                       9

2.    Age of Iron and Steam                                 29

3.    Commerce and Industry                                 53

4.    Public Life                                           79

5.    Society and Culture                                  103

Bibliography                                               126

About the Huntington County Historical Museum              127

# ACKNOWLEDGMENTS

The authors would like to thank the following individuals and organizations for their help in preparing this project: Randy Neuman of the United Brethren Historical Center for helping us procure the initial photographs for the book proposal; Susan and Jim Taylor of Historic Forks of the Wabash for allowing us to use their photographs and display materials; Dan Johns for identifying some wonderful photographs from the collection at the Quayle Vice Presidential Learning Center; the board members of the Huntington County Historical Museum for allowing us access to the museum's collection; and Monte and Jim Davis for their photographs and stories of "Johnny." Thanks also to Lee, Don, and Mike at the Rusty Dog for their ideas and enthusiasm for the project.

We would also like to thank Rebecca Mullens, our student worker, who scanned hundreds of photographs and transcribed any and all information relating to those photographs, and Paul Nalliah for helping us with the high-resolution scanner, without which many of these photographs could not appear in the book.

We would especially like to thank Sarah Schmidt at the Huntington County Historical Museum, who went above and beyond in helping us find photographs and track down information not readily at hand. Many thanks are also owed to Jean Gernand, who provided valuable feedback on the content and accuracy of the information provided in this book. Still, any errors or oversights in the book fall solely on the authors.

Unless otherwise noted, all images appear courtesy of the Huntington County Historical Museum.

# INTRODUCTION

Huntington, Indiana, is situated along the Wabash River, where French, English, and Indian traders met to exchange goods and conduct diplomacy. Historian Richard White referred to this region where European and Native American cultures met as the "Middle Ground." Huntington's location at the center of the Ohio Valley-Great Lakes Region placed it in the middle of a stretch of land that the new nation endeavored to acquire and secure in its infancy. Many years later, when sociologists Robert and Helen Lynd went looking for a typical American town—Middletown—to study changes in American society and culture in the 19th and 20th centuries, they picked a town in Indiana. If one is looking for a town that represents "Middle America," Huntington is the place.

Huntington sprawls across the confluence of the Wabash and Little Rivers about 30 miles southwest of Fort Wayne adjacent to a site known as the Forks of the Wabash. Before settlers from the East Coast arrived, Native Americans of the Miami tribe occupied the ridges above the Forks and lived off the valley's abundant game and fresh spring water. The rivers offered an excellent means of transit between Miami villages all along the Wabash River corridor from present-day western Ohio to southwestern Indiana. The location was a strategic one as it sat astride the crossing point of river passages linking east to west along a route that offered travelers the shortest path from Lake Erie to the Mississippi River.

For many years in the 18th and early 19th centuries, French and British trappers, merchants, and missionaries appeared in these Miami villages and conducted a regular trade in flour, liquor, furs, and other articles. The eventual fate of the region was determined by wars between the United States and confederations of Native American tribes in 1794 and 1811. The treaties that concluded these wars, coupled with Indiana's admission to the United States in 1816, opened northeastern Indiana to settlement by white farmers and tradesmen. In 1828, Artemus Woodworth built a log cabin above the Wabash River near the site of Huntington. Then, in 1831, Champion and Joel Helvey erected a very large log structure and named it the Flint Springs Hotel, in anticipation of business from the Wabash and Erie Canal, which was projected to run through the area when completed in the 1830s.

The canal boom of the 1820s and 1830s served as a catalyst for Huntington's development as a regionally significant town. Gen. John Tipton, who led a militia at the Battle of Tippecanoe in 1811 and then served in the War of 1812, acquired land on the banks of the Little River. In 1833, Tipton's agent, Capt. Elias Murray, surveyed and platted the town's streets. Murray gave the town its name in honor of Samuel Huntington, his uncle, who was a signer of the Declaration of Independence. Tipton donated plots of land for government buildings, and Huntington was named the county seat in 1834. On one of the plots, Tipton built the first county courthouse; the first court convened in the new courthouse in March 1841. Eight years later, in 1848, the city of Huntington was officially incorporated by the state.

As the city moved through its early stages of political organization, pioneers broke ground and established homesteads in anticipation of the economic opportunities afforded by the canal's regular transit to markets in the East. The canal company built three locks in the town and ensured that the location would serve as a linchpin in the new nation's transportation system. Construction workers and canal employees took up residence and created demand for the products of the area's farms and workshops. They built warehouses to hold goods coming and going along the eventual

468-mile length of the Wabash and Erie Canal. Settlers from Ohio and Pennsylvania, as well as Germany and Ireland, filled up the town and countryside and began to live alongside the Miamis. Some Miamis accepted payment for their land and left in 1846 on canal boats headed for Kansas and, eventually, Oklahoma.

The canal boom lasted only a few short years due to the increased scale and economic efficiency offered by railroads, which began to appear along canal routes in the 1840s and 1850s. Huntington entered a new phase in its history when the Wabash Railroad built a line through town and connected the city to the nation's growing network of rail lines. The railroad not only altered the appearance of the city's landscape, it also invigorated the area's economy and steered its development toward industry. County farmers still raised hogs and corn, and the area's mills sent lumber and flour to Fort Wayne, Chicago, and elsewhere. Stone quarries also remained an important source of income for local entrepreneurs, so much so that Huntington acquired the nickname "Lime City." However, factory production grew in importance, and industrial workers and their families began to populate the town. By the mid-20th-century, companies like Majestic and Sealtest, and more recently Bendix, Ecolab, Transwheel, and Homier Distributing, employed hundreds of local residents, and manufacturing joined transportation, retail, and professional services as the basis of the local economy in modern times.

In the last half-century, federal and state development projects gave Huntington's landscape a significant makeover. In 1968, the US Army Corps of Engineers finished the J. Edward Roush Dam in order to control flooding on the Wabash River. The dam's reservoir and its surrounding wooded areas provide residents with recreational opportunities like boating, fishing, and hunting. In the same year, state highway officials opened the Route 24 Bypass around the north and west of town. This improvement provided new opportunities and new challenges; trucking companies and national retail chain stores benefited from the new traffic pattern, while the old downtown district suffered a slow decline in business. In recent years, Huntington's public life has been dominated by the issues associated with downtown revitalization and school consolidation as city officials react to a changing economic climate and a shifting population.

These issues are familiar to people living in towns throughout Middle America. Like elsewhere, Huntington's volunteer organizations make an important contribution to civic vitality, with a wide range of social clubs and charitable organizations like the Boys and Girls Club, Tri Kappa, Lions Club, Moose Lodge, Kiwanis, Veterans of Foreign Wars (VFW), Youth Services Bureau, and more providing opportunities for socializing and contributing to the town's betterment. Huntington's 17,300 residents worship in more than 25 churches and come together in annual community gatherings like the Forks of the Wabash Pioneer Festival, Huntington Heritage Days, and the 4-H Fair. In other ways, Huntington is unique. It is home to a cluster of Catholic institutions, including the Our Lady of Victory Missionary Sisters community, known locally as Victory Noll; the St. Felix Catholic Center, a historic friary; and Our Sunday Visitor, a national Catholic publishing company. Huntington is also the birthplace and home of former Vice President Dan Quayle.

The images in this book offer a glimpse of Huntington's past, with all the familiar features of small-town life and a little charm all of its own.

# One

# THE FOUNDING ERA

The earliest people who came to the place where the Little and Wabash Rivers come together at the Forks of the Wabash were drawn by the area's natural resources. Native Americans who were present in what is now Huntington in the early 19th century were there to take advantage of the wild game, freshwater, and flint they found in the area's forests and streams. The Miamis also appreciated the location's strategic value as a hub for water transit in multiple directions: northeast toward the headwaters of rivers that carried people, furs, and news into the Great Lakes and beyond, and southwest toward the Ohio River and, eventually, the Mississippi. Early American homesteaders carried on these practices, seeking lumber and farmland in lieu of game and flint and shipping cargo on mule-drawn canal boats in lieu of canoes.

Pioneering's hardships were numerous and varied. Thick forest cover had to be cleared to make way for agriculture. Once built, Huntington's houses and barns lay exposed to flooding along the Wabash River. Canal beds, towpaths, locks, and warehouses consumed years of sweat and toil, and the canal occasionally dried up when spring rains failed to materialize. Improvements in roads and waterways compressed the long distances between the settlers and their homes back east, but Huntington's remoteness brought abundant challenges. The pioneering era was challenging for the Miamis as well. For them, the coming of white settlers and the purchase of tribal lands led to divisions in the tribe between those who chose to remain and assimilate and those who left to take up residence in the West. Huntington's inhabitants persisted through all these difficulties, and by 1850 they had established a bustling river town, a hub of commerce for the farmers, tradesmen, and merchants of northeastern Indiana.

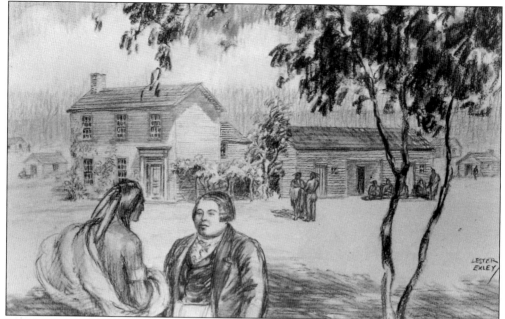

In 1834, William Marshall, a representative for the federal government, concluded an agreement with the Miami to cede Indian lands reserved in the Treaty of 1826 in exchange for $208,000 and individual land grants to several Miami leaders. The Miami cession paved the way for construction of the Wabash and Erie Canal and for the town of Huntington to be organized. (Courtesy of Historic Forks of the Wabash.)

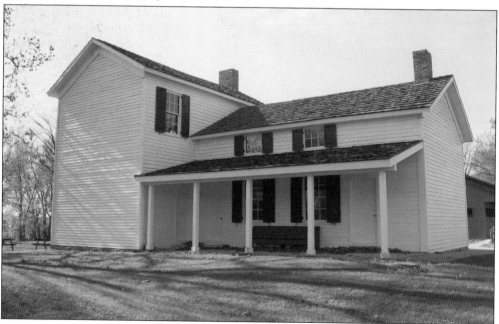

Miami chief Jean Baptiste Richardville (Miami name: Peshewa) had this house built in 1833 for the purpose of treaty negotiations with US officials. It was also used for Miami Council meetings and for visits by Chief Richardville, who lived in Fort Wayne, to local Miami villages. (Photograph by Jeffrey Webb.)

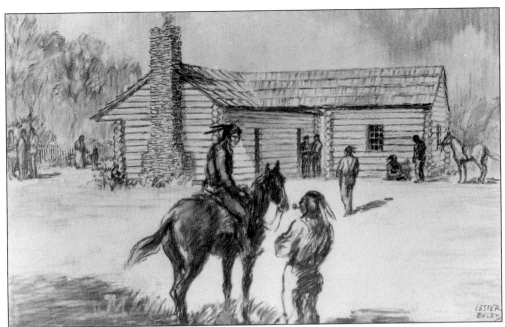

This artist's conception of the Indian Agency House depicts the prominence of the stone chimney, which at one time was all that remained of the house. Located south of the Wabash River, the house was supposedly built by Henry Reed and his wife, Susan, the youngest daughter of Chief Richardville. It was here that the first government payment to the Indians was made. (Courtesy of Historic Forks of the Wabash.)

Chief Richardville built a log cabin with a large chimney, pictured here, on the south bank of the Wabash River at the Forks of the Wabash. His daughter Susan and her French husband lived there. Later, the cabin was used for the distribution of annuities owed by the federal government to the Miami residents of the area. Historic Forks of the Wabash board members and volunteers have preserved all that remains of this building. (Courtesy of Historic Forks of the Wabash.)

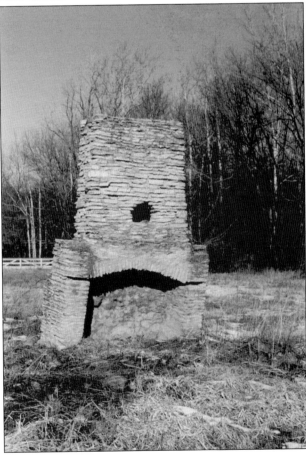

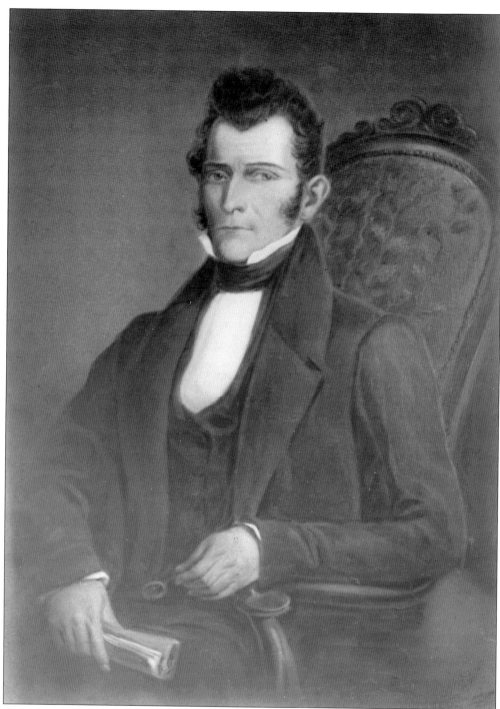

Gen. John Tipton moved to Indiana from Tennessee in 1803 at the age of 17 and then fought with William Henry Harrison in the Battle of Tippecanoe in 1811. He commanded a unit of the Indiana Militia in the War of 1812 and received promotion to brigadier general. He bought land on the banks of the Little River, anticipating the future importance of this location to an expanding nation, and then donated the land upon which the county courthouse now stands.

This statue of Chief Little Turtle of the Miami Indians, created by Diana Sowder (right), was on display at the First National Bank on the Jefferson Mall in November 1979. At left is Robert Owens, chairman of the Miami Indians of the Indiana Reorganization Council and a descendant of Miami Indian Chiefs Richardville and LaFontaine, of the Forks of the Wabash, near Huntington.

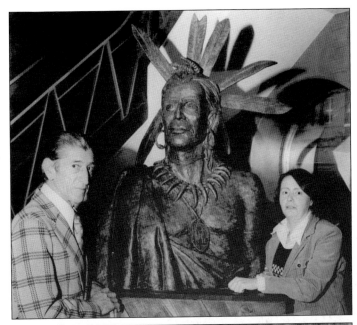

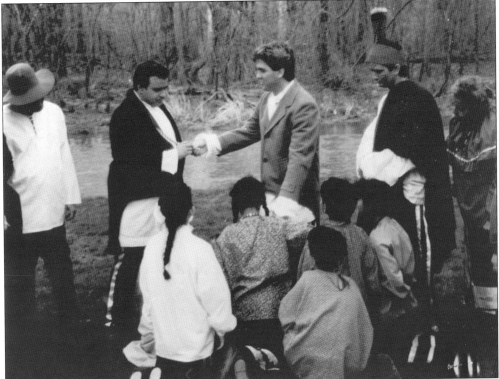

The Historic Forks of the Wabash is the site of reenactments like the one pictured here. The event is commemorating the signing of the treaty in 1834 by which the federal government received Miami lands in exchange for cash and several land allotments given to select Miami leaders. This treaty placed the Miami people at risk of removal to the West and of division into two distinct groups. (Courtesy of Historic Forks of the Wabash.)

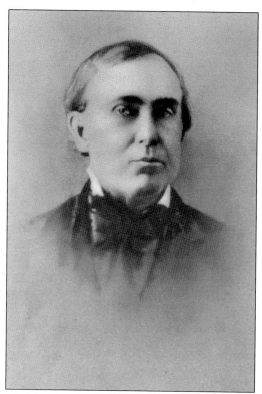

Capt. Elias Murray served as an agent for Gen. John Tipton and was among Huntington's first white settlers in 1829 or 1830. Murray laid out the street plan for Huntington, which he named in honor of Samuel Huntington, his uncle and a signer of the Declaration of Independence. He was one of the chief officials at the ground-breaking for the Wabash and Erie Canal on February 22, 1832, the date of George Washington's birthday.

At the Historic Forks of the Wabash, preservationists maintain original log homes like the Nuck House, pictured here. The Nuck House was originally built two miles north of the Forks in 1847 by Joseph and Margaret Nuck, German emigrants who traveled from Bavaria to the United States and came into the area by way of the Wabash and Erie Canal. The house was moved to the Historic Forks of the Wabash in 1981 and maintained in its canal-era appearance. (Photograph by Jeffrey Webb.)

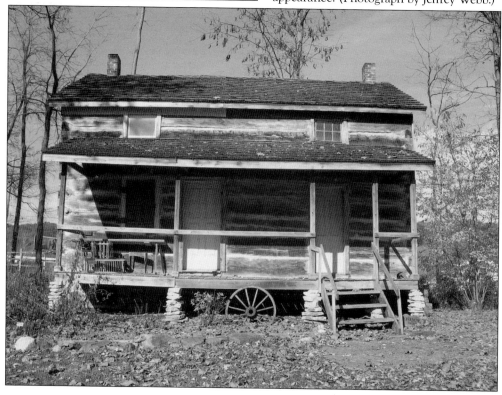

The woman on the left in this portrait is Mary Cecilia Murray, the daughter of Capt. Elias Murray and his fourth wife, accompanied by an unknown relative. Not much is known about Mary Cecilia; her father served as county treasurer and represented the county in the state legislature in 1841, but he eventually moved from Huntington to Wabash County to plot the town of Lagro.

This building, dating from the latter half of the 19th century, was moved to the Forks of the Wabash from its prior location on Waterworks Road. It is currently used to depict a trading post in the early 18th century. French traders brought musket balls, axes, scissors, needles, fabric, brandy, knives, and other items to trade with the Miamis for furs. (Photograph by Jeffrey Webb.)

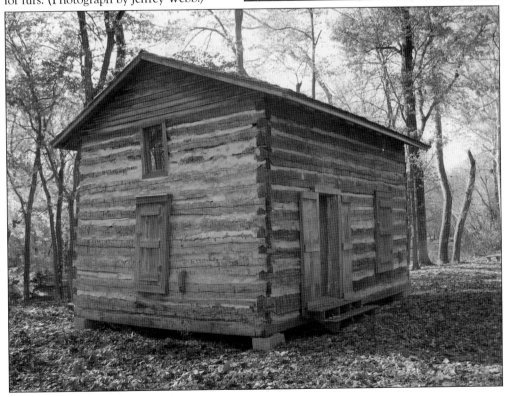

Huntington's 19th-century settlers built their homes, barns, and churches out of hewn logs and other materials at hand. By the late 1840s, residents who could afford the expense began erecting brick buildings, which gave the town a more familiar appearance to settlers arriving from eastern states. Today, Huntington celebrates its pioneer heritage with the Forks of the Wabash Pioneer Festival, which began in 1976 and is held annually in September.

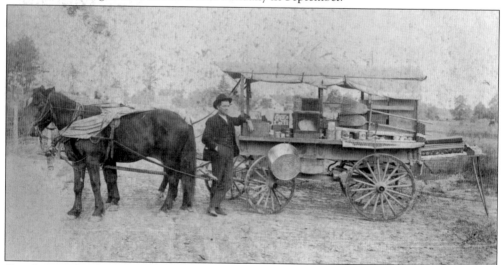

Canal-era settlers bought dry goods from peddlers like Bill Spaulding, pictured here, who plied the area's wagon roads when weather permitted. Regular barge traffic on the Wabash and Erie Canal ensured a steady supply of necessaries and provided farmers with the tools needed to break ground and cultivate the soil. Dry goods stores put traveling peddlers out of business when population growth allowed for their profitability.

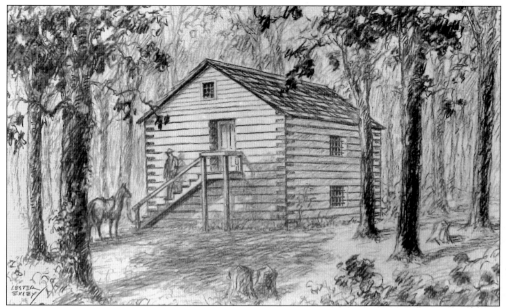

Huntington County's first jail is shown in this drawing. It was a log cabin structure built by William H. Wallis in 1835 for $400. Its design was unusual: inmates climbed down a ladder into their first-floor cells through a trap door on the second floor, and then the ladder was withdrawn. Some of the first inmates were John Morgan and John Muhlanan, who were detained in 1836 on charges of robbery.

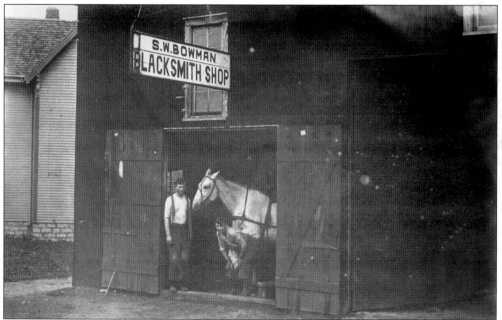

The S.W. Bowman Blacksmith Shop, on Huntington's south side, appears in this photograph from the late 19th century. Huntington's rustic conditions placed enormous demands on its early settlers, who met these demands with strength and determination. Tradesmen were crucial in this effort, since pioneer villages required the labor of people trained to frame houses and boats, fabricate metal tools and fittings, operate and repair mills, and work teams of horses.

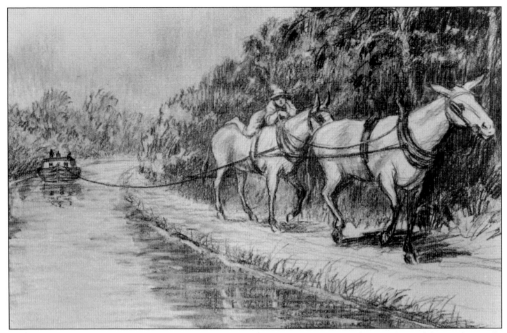

Canal boats required workers to load freight, serve passengers, steer the craft, and drive the mule team. This demand for labor helped populate Huntington with settlers from the East and South in its early years. Canal boats came in two basic types: packet (passenger) and freight. Travel was typically slow, although laws limiting speeds to three to five miles per hour were often ignored. (Courtesy of Historic Forks of the Wabash.)

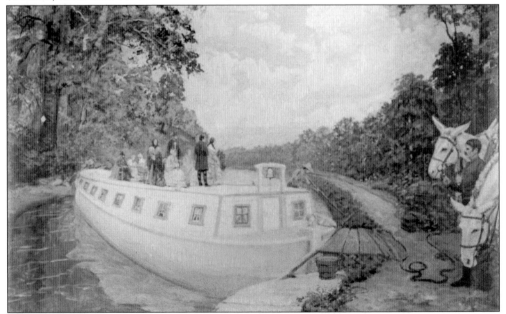

*The Mosquito Boat*, an artist's conception commissioned by James Bippus in 1928, depicts a boat that would transport people along the Wabash and Erie Canal. It was referred to as a "mosquito boat" because of the numerous mosquitoes along the canal, which often drove passengers inside to avoid being bitten. (Courtesy of Historic Forks of the Wabash.)

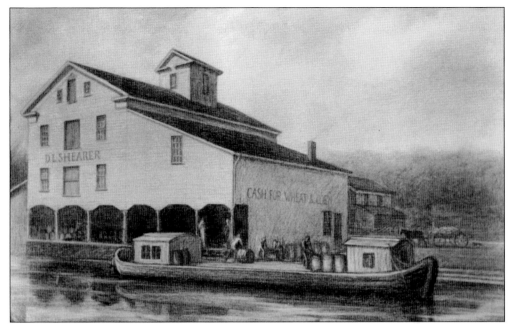

This drawing depicts the D.L. Shearer warehouse, which was built in 1853 on the canal's north bank. Shearer's operation facilitated commerce between local farmers and distant markets, where demand for commodities was rising in the pre–Civil War years. Shearer's warehouse was purchased by the Wabash Railroad in 1902 and moved to the downtown area near Court and First Streets. (Courtesy of Historic Forks of the Wabash.)

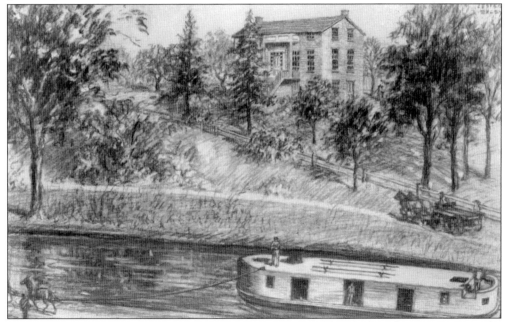

The Samuel Hawley house, seen in this artist's conception, was likely built in the 1830s. It sat on the plot of land marked off to the east by College Avenue and Division Street, overlooking what was once part of the canal. Hawley acquired the original five acres of land to start a nursery. He later added more acreage to expand his successful business. (Courtesy of Historic Forks of the Wabash.)

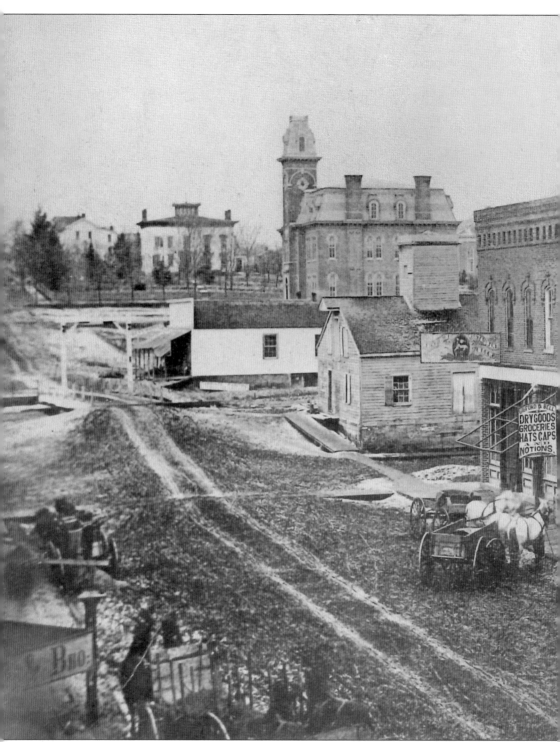

This picture from the mid-19th-century depicts the Wabash and Erie Canal running through downtown Huntington. Unpaved streets and horse-drawn carts reflect the town's rustic state before the railroads, when the Gibford & Bell and Crabbs, Strodel & Co. dry goods stores (foreground)

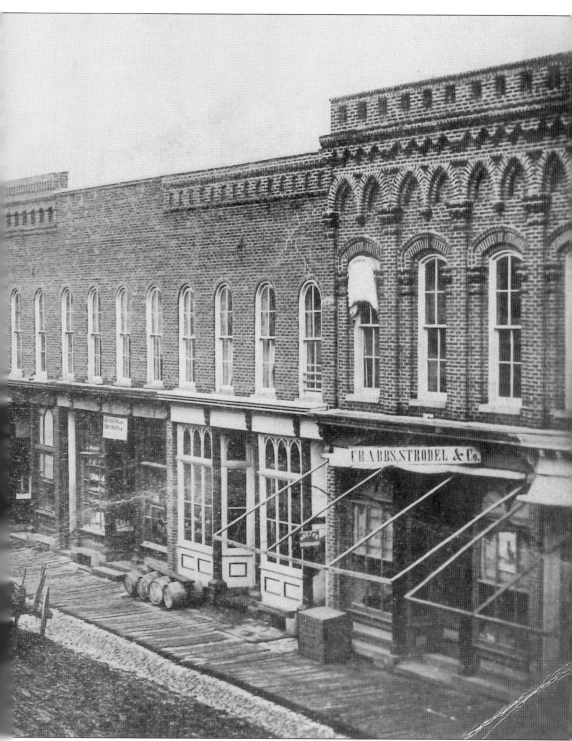

served the community. John Strodel (1850–1896) came to Huntington from Germany at the age of five. He then joined Parry Crabbs for a few years before running his own very successful department store in the 1880s and 1890s.

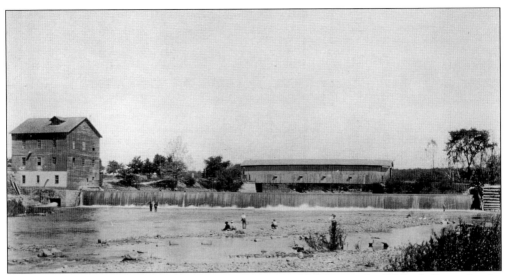

Taken shortly after 1900, this photograph shows men fishing in the Wabash River. In the background is the covered bridge that used to span the river as part of Etna Avenue, while to the left, along the river, is the Coon & Coll sawmill. The area also housed a cider mill, a blacksmith shop, and a gristmill.

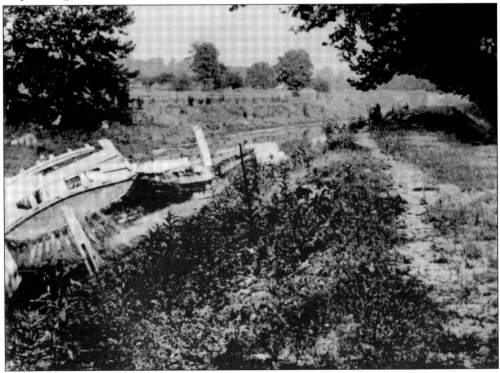

The brief canal era ended in the 1870s following the appearance of the railroads in northeastern Indiana. Canals were expensive, and the unpredictable weather combined with interruptions in service made it difficult for investors to bring canal operations to profitability. This photograph, believed to have been taken in 1874, shows the decaying remnants of the last canal boat. (Courtesy of Historic Forks of the Wabash.)

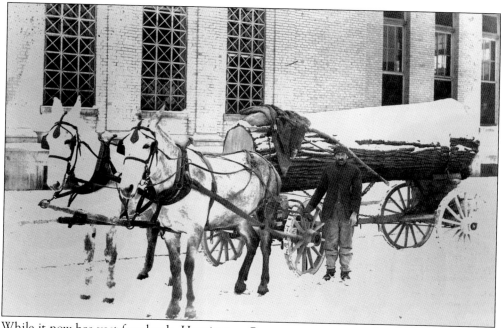

While it now has vast farmlands, Huntington County was once graced with a fine hardwood forest. Beginning in 1848, much of the forest was cut down and sent to eastern markets—the likely source of Huntington University's mascot, Norm the Forester. Kenower Lumber Company was one of the main lumber mills in the area. Here, outside the old post office on Market Street, Charles Foust transports a log to the mill.

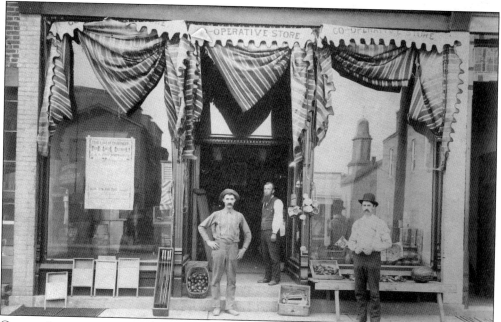

Cooperative stores were part of a movement in which individuals banded together to gain economic clout. Most often formed for the benefit of famers, co-ops like this one from the 1890s helped farmers keep costs low by the joint purchasing of supplies and the joint sale of crops to obtain the best prices. Unfortunately, many co-ops failed because of insufficient capital or poor management.

This is a portrait of Mary Winters taken around 1860. Mary's husband, Samuel, supported Lambdin P. Milligan, whose actions during the Civil War resulted in charges of treason and a military trial. Winters and Milligan were members of the Order of American Knights, which claimed to be a states-rights political action committee. The order was accused of involvement with the Northwest Conspiracy to undermine Union authority in the Great Lakes region.

Lambdin P. Milligan (1812–1899) was an attorney who became famous for his political activities. He was a states-rights Democrat and helped organize the Knights of the Golden Circle, which was accused of antigovernment activities in the 1860s. His arrest, conviction, and appeal established an important principal in civil liberties: civilians cannot be tried in military courts if civilian courts are in operation. (Photograph by Jeffrey Webb.)

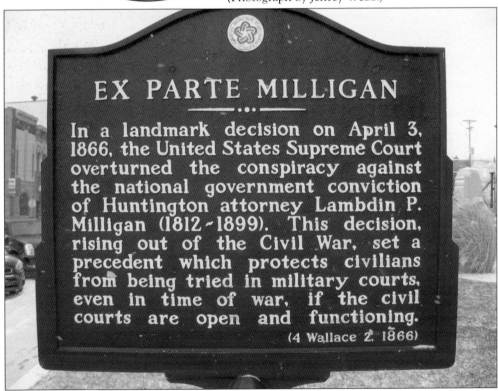

## EX PARTE MILLIGAN

In a landmark decision on April 3, 1866, the United States Supreme Court overturned the conspiracy against the national government conviction of Huntington attorney Lambdin P. Milligan (1812 - 1899). This decision, rising out of the Civil War, set a precedent which protects civilians from being tried in military courts, even in time of war, if the civil courts are open and functioning.

(4 Wallace 2, 1866)

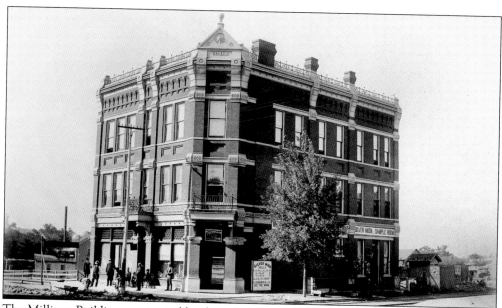

The Milligan Building, contracted by the infamous Lambdin Milligan, was completed in 1883. Now part of a block of five adjoining Italianate buildings, the main corner building, shown here around 1900, was home to the Silver Moon Saloon, whose placard sits outside the entranceway. Having served various purposes over the years, the Milligan Building is now an Irish pub, the Rusty Dog—a local favorite.

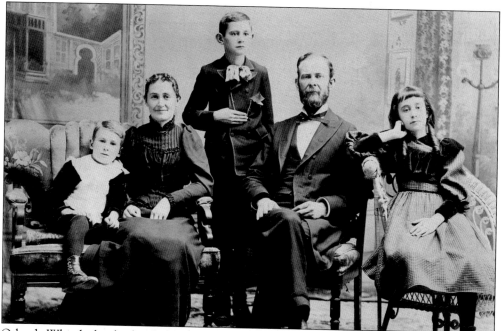

Orlando Whitelock, a leading businessman in Huntington at the end of the 19th century, practiced law with Lambdin Milligan. He also ran an early printing press in town, editing and publishing the *News-Democrat*. Whitelock's oldest son, Wilfred, later took over the newspaper. His youngest son, Charles, died in 1917 during World War I after enlisting in the Ambulance Corps. Pictured also are his wife, Lydia, and daughter Mary.

The James Bratton house was the first brick house on the south side of the Little River, built in 1852 on South Jefferson Street near Etna Avenue. The house had an atrium at its center, though it was eventually closed off. Bratton played a role in 1864 in the arrest of Lambdin Milligan on a count of treason in his role as local "provo." Bratton later served as sheriff in 1886.

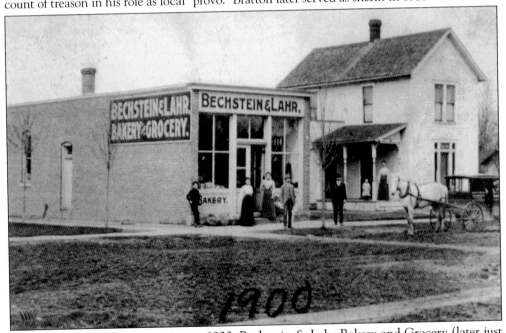

Shown here shortly after opening in 1900, Bechstein & Lahr Bakery and Grocery (later just Bechstein's) was one of the longest-running family-owned businesses in Huntington. The store held out against its competitors long enough to celebrate its 100th year in operation, closing in 2000. The building is now occupied by Love, Inc., a local charity that works with churches to help meet the needs of the community.

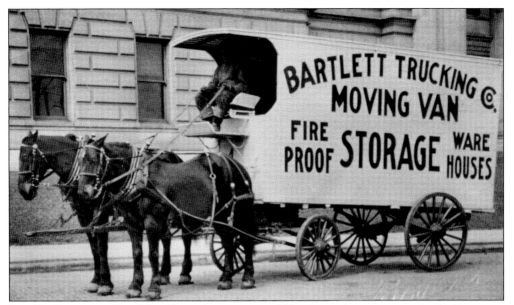

Bert Bartlett, originally of New Hampshire, was one of Huntington's more progressive businessmen. The Bartlett Trucking Company, begun in the early 1890s, was his most successful business. Originally engaged in the lumber business with a Mr. Perine, Bartlett eventually sold out his share and began his trucking and transfer enterprise, which employed several men and teams.

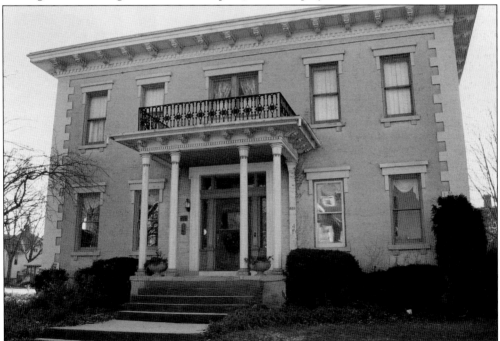

The Samuel Purviance House was built at 326 South Jefferson Street in the Italianate style. It was named for its owner, the founder and president of the First National Bank of Huntington. The second house built on the south side of the Little River, it is now the oldest that still stands. It later became home to Elizabeth's Tea Room, which offers service at lunchtime hours. (Photograph by Jeffrey Webb.)

Pictured here is a gathering of descendants of Chief Francis La Fontaine (Miami name: Topeah), the principal Miami chief in the 1840s following the tenure of his father-in-law, Chief Richardville. Sitting in the center is La Fontaine's daughter Archangel La Fontaine Engelman, just a few years before her death in 1925. (Courtesy of Historic Forks of the Wabash.)

# Two

# AGE OF IRON AND STEAM

The Wabash and Erie Canal thrived for only a few years in the mid-19th-century. Canals were prone to unpredictable weather conditions and breakdowns in service, and they never produced a volume of traffic sufficient to recover their construction costs. Railroads offered a remedy for all of the canal's many ills. Where canals were limited to speeds of three to five miles per hour, steam engines could go 30 miles per hour. Trains carried greater volume at lower costs with fewer interruptions in service. Given these advantages, and Huntington's location, it was certain that rail service through Indiana would appear at a very early stage in the city. Local figures like John Roche, Lambdin Milligan, John Ziegler, David Shearer, Jesse Davies, and Samuel Moore lobbied for the Wabash Railroad to chart a course through Huntington. Through their efforts, the company began to lay track in 1853. In early 1856, the town enjoyed its first regular passenger and freight service.

The coming of iron rails and steam engines sparked a transformation of the city that proved to be as far reaching as it was long lasting. The railroad brought telegraph lines through town, which connected Huntington to the nation's growing communications network. Rail transit increased the trade in lime, for which Huntington had acquired a growing reputation. In 1860, only two commercial limekilns existed; by 1875, a countywide survey found 31 in operation, with Huntington at the center of an expanding local industry. With greater access to distant places and rising land values, the town's population grew from 594 residents in 1850 to 2,925 in 1870 and 9,491 in 1900. The growing city had pressing needs for more housing, paved streets, water and sewer works, schools and parks, and police and fire protection, all of which soon arrived to give Huntington its modern character.

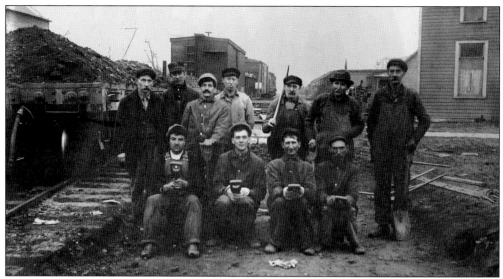

Wabash Railroad workers break from digging to pose for the camera. After much lobbying by local leaders, the Wabash Railroad was routed through Huntington and opened for business in 1856, offering competition to the canals in northeastern Indiana. Other railroad companies operated on the line and built rail yards in town. Engineers and maintenance workers from these companies settled in the area and contributed to Huntington's economic vitality.

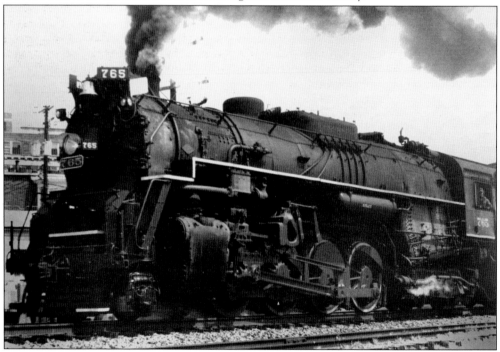

One of the more famous steam engines in the history of railroading in the United States is the Nickel Plate 765, known by its nickname, the "Wabash Cannonball," as seen in this image. The "Wabash Cannonball" ran along the Nickel Plate Road, a rail system in the Midwest that operated from 1881 to 1964, connecting Buffalo, Cleveland, Indianapolis, Chicago, and St. Louis. The "Wabash Cannonball" was celebrated in songs and folklore in the early 20th century.

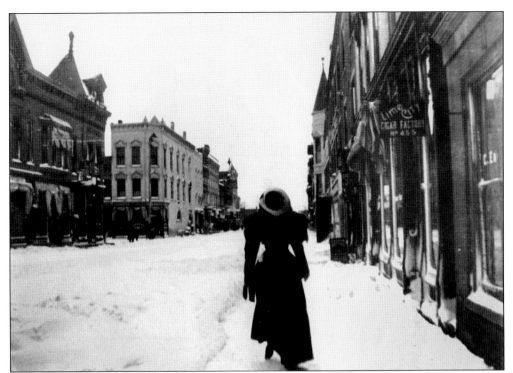

In this photograph from early 1900, Jefferson Street lies covered in a blanket of snow. One of the businesses seen here, the Lime City Cigar Factory, moved from its prior location above Weise's Saloon, at 83 North Jefferson Street, after it was consumed by a fire in 1894. Four years later, Louis Kronmiller and Nick Petrie bought the business from its former owner, John L. Brown, who acquired it from founder Frank Gift.

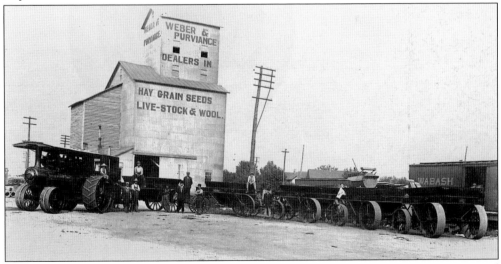

Unloaded from the Wabash Railroad in June 1912, Mr. Schell's new hauling equipment consisted of a 35-horsepower Port Huron traction engine and five self-spreading stone-hauling cars. The steam-powered tractor, manufactured by the Port Huron Engine & Thresher Company in Michigan, weighed up to 22,000 pounds. The stone hauled by this equipment helped to pave much of southern Huntington County.

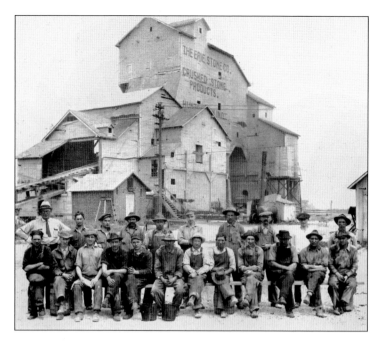

According to the 1901 *Biographical Memoirs of Huntington County*, no other early industry boosted Huntington's reputation as much as the lime trade. By the early 1900s, Huntington County was one of the largest producers of limestone in the state, gaining the county seat the name of "Lime City." Pictured here in the early 20th century are workers at the Erie Stone Company, east of Huntington at the quarry that is now Lake Clare.

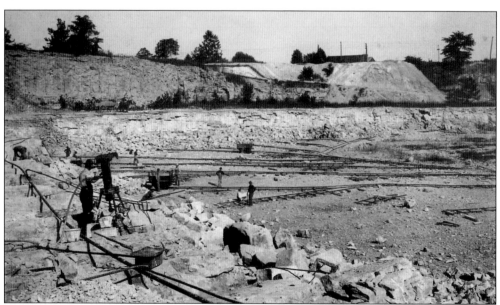

While the quality of the lime from Huntington meant that much of it was shipped out of the state, much of the crushed stone was used locally for railroad ballasts and heavy construction. When it was first discovered that Huntington had an abundance of gravel, work began on improving the roads in the county. The gravel was a significant improvement over rotting wood-plank roads. Pictured here are workers in a local quarry.

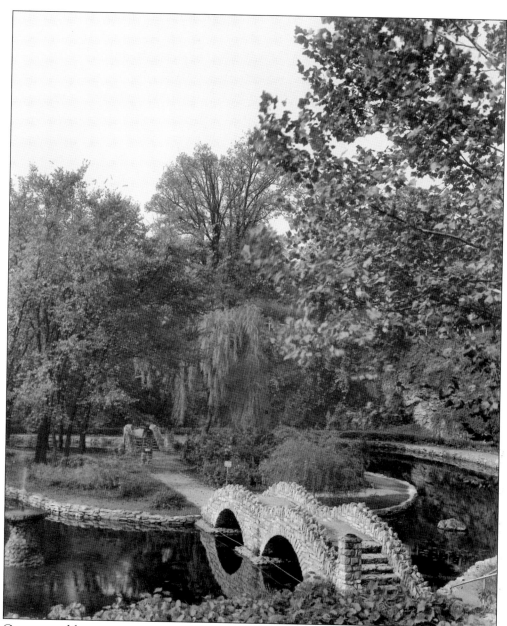

Constructed between 1923 and 1929, the Sunken Gardens was a civic project dedicated to repurposing an abandoned limestone quarry along Park Drive. The desire was to promote the spot as a tourist attraction to lure the increasing numbers of passing motorists to the area. During the 1930s especially, the gardens provided a nice place for a cheap family picnic, and they still offer a great setting for wedding photographs. Designed by Chicago landscape architects Blarry & Rary, the Sunken Gardens include a variety of flora and fauna spread among footbridges, fountains, and fieldstone staircases. It even has a pool-ringed peninsula. The gardens can be seen from the road along the West Park Drive Bridge, made of a low, pillared wall of fieldstones. The gardens are lighted with Christmas decorations during the holidays.

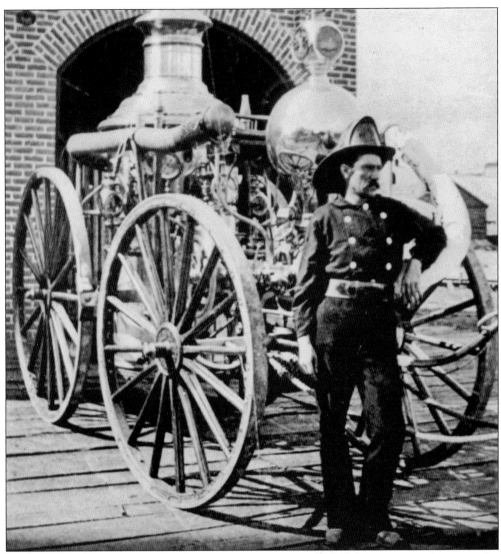

Huntington's population reached 594 in the 1850 US census. With their town numbering in the hundreds, officials organized the first volunteer firefighting company in 1856. By the 1880s, the fire department was large enough to have 130 men divided into four companies, with two horse-drawn steam engines and a large, two-story brick engine house, seen in the background of this late-19th-century photograph. In the 20th century, professional firemen replaced volunteers. In recent years, the city fire department had 37 firefighters on staff.

This photograph, taken around 1900, captures workers of the City Bakery showing off their freshly baked loaves of bread. The City Bakery was opened in November 1886 by brothers Jesse and George Buchanan, the second and third sons of Samuel and Mary (Weist) Buchanan. The bakery was located at 531 Franklin Street.

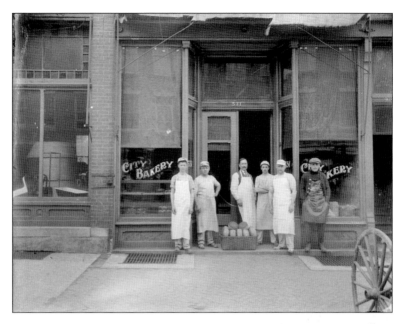

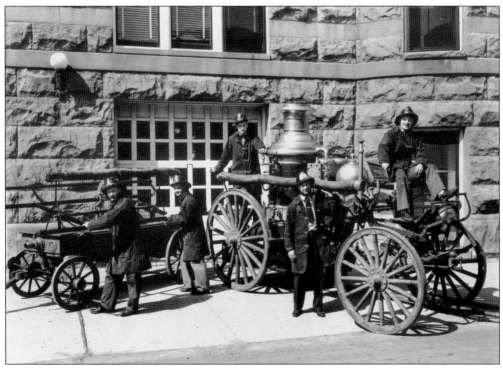

This 1948 photograph shows Huntington firemen with obsolete equipment, a horse-drawn hose cart and steam engine, purchased from businesses like the Ahrens Manufacturing Company of Cincinnati. Ahrens marketed the "Continental" and "Modern Double Ahrens" engines to municipalities rapidly professionalizing their staff with trained and paid firemen in order to keep pace with other "modern" towns in the Gilded Age in competition for new businesses and new home buyers.

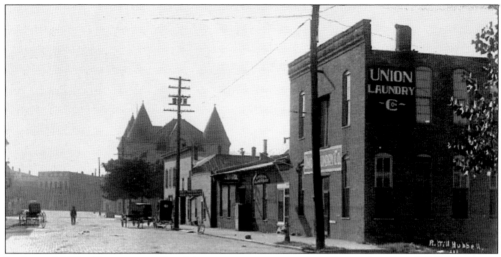

In the mid-1870s, Huntington officials began paving city streets with gravel, and in 1893 Washington and William Streets were paved in brick; other downtown streets soon followed. In this 1911 photograph, taken on Cherry Street looking south toward the City Building from Washington Street, the results of this paving program are seen. The appearance of Cherry Street also changed with the coming of electricity only a few years after 1900.

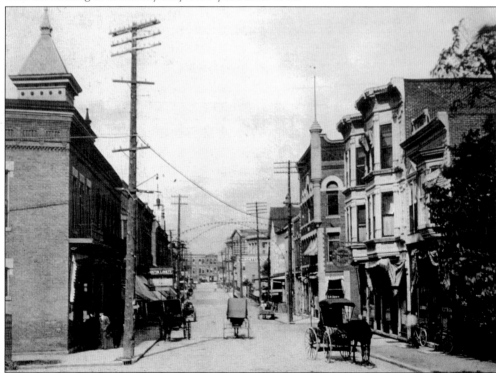

This 1911 view of Jefferson Street looking north from Etna Avenue shows a part of Huntington that has since been torn down. The Mayne Building, housing the Kocher Grocery, is on the left. On the right with the bay windows is the old United Brethren Publishing building. The Whitelock Press office is on the right, just across the river. The courthouse is just visible in the center right.

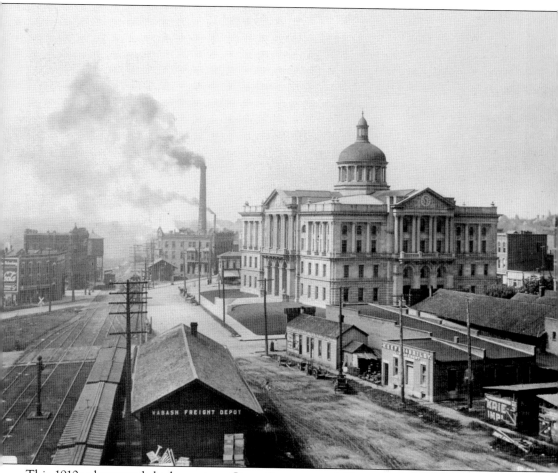

This 1910s photograph looks west on Court Street toward Huntington Light and Fuel. The new county courthouse at Court, Warren, Jefferson, and Franklin Streets was finished in 1908. Together with the electric company, the two buildings set the tone of development in Huntington for the new century. The business in the lower right, Keefer & Bailey, specialized in lime and cement production.

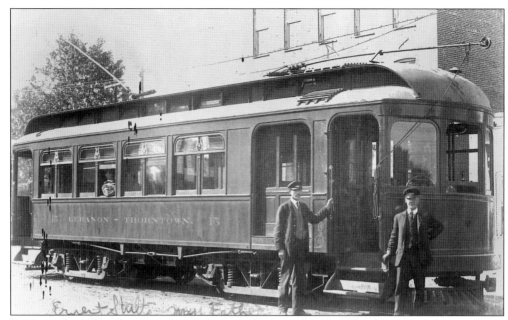

Begun in the 1890s, the interurban railway was built on the towpath of the old Wabash and Erie Canal. Although it eventually switched from steam to electricity, by 1900 the interurban had become the biggest network of electric railways in the nation, linking numerous Indiana towns. The first interurban arrived in Huntington from Fort Wayne on December 12, 1901. One of the conductors shown here is Ernest Stults.

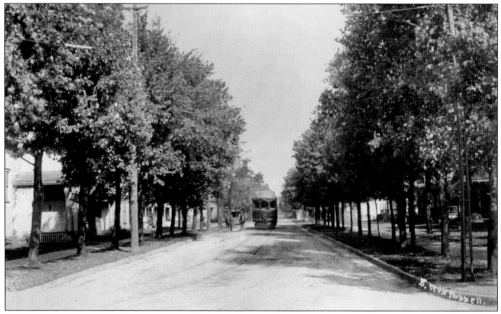

Connecting the Huntington populace with Indianapolis, Fort Wayne, and other towns, the interurban ran over Market and First Streets with as many as 32 runs throughout the day. The cars' cruising speed was 55–60 miles per hour, and the line was known for its dependable service. One of the passenger stations was located on Market Street, between Warren and Guilford Streets. The interurban stopped running in Huntington in 1938.

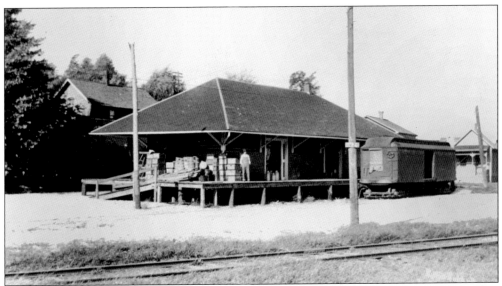

While many interurban cars were designed for passengers and were brightly colored in either orange, red, yellow, or green with names like the "Marion Flyer" and the "Muncie Meteor," the line also transported freight. Pictured here is the interurban freight house, located in Huntington at the end of West State Street on LaFontaine Street. When the terminal was abandoned by the interurban in 1938, it became a truck terminal.

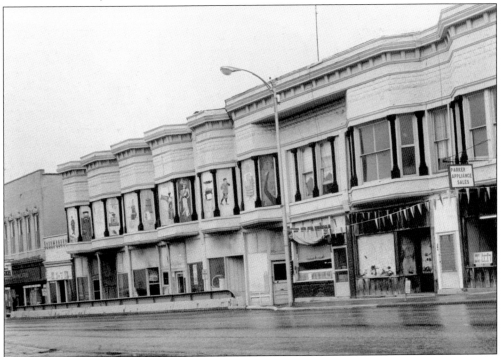

These buildings, erected in the early 1900s over the Little River, housed shops, offices, and dwellings for over a half-century but were condemned in 1966. Attempts were made in the 1970s to renovate the buildings, but the State of Indiana ordered the razing of the buildings, which was completed in July 1977.

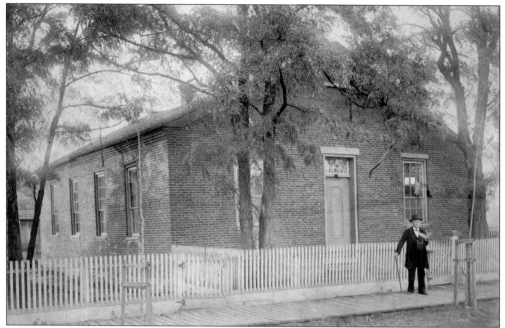

Torn down in 1893, the original First Baptist Church building—the first Protestant church in Huntington—was erected in 1847 on West Market Street by a Baptist colony from New Carlisle, Ohio. Elizabeth Purviance (née Montgomery) was the daughter of one of the founding members. The building was sold in 1867 when the congregation built a new church on East Market Street, where the First Baptist Church still holds services.

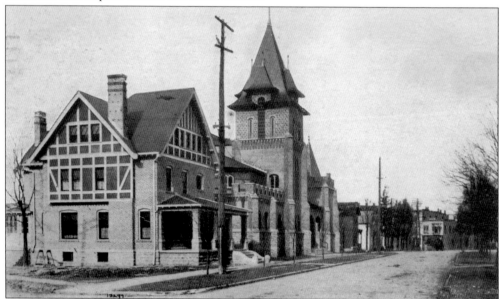

The German Reformed Church began in 1856, and the congregation worshipped in a building on a lot donated by one of its members, Henry Drover, at the corner of Etna and Henry Streets. Drover owned a canal boat fleet and bought 160 acres on the south side of town, which he plotted and sold to German immigrants. The city annexed what was known as Drover Town in 1874. In 1904, the congregation built the church seen here in the early 20th century.

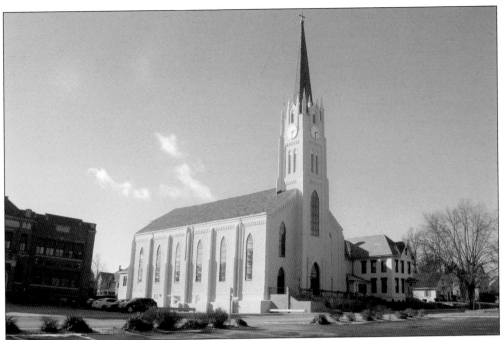

As the German Catholic population increased, brought by the canals and other job opportunities, residents decided in 1840 to build a church on property provided by Chief Richardville. The first Mass was held in a log church in 1843, and the congregation gained its first resident pastor in 1857. Eventually, around 1865, the log chapel was replaced by the current brick structure of Ss. Peter and Paul Church. (Photograph by Jeffrey Webb.)

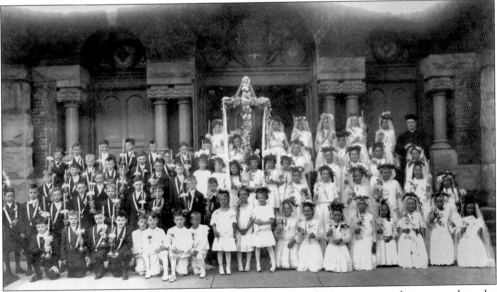

Ss. Peter and Paul Church was established for a predominantly German population, so when the railroad brought in many new Irish workers, Bridget Roche provided the capital to build a church for the English-speaking population of the community in honor of her brother John Roche. The church building for St. Mary's parish was dedicated in 1897. Here, young celebrants pose in front of St. Mary's after their first communion in 1910.

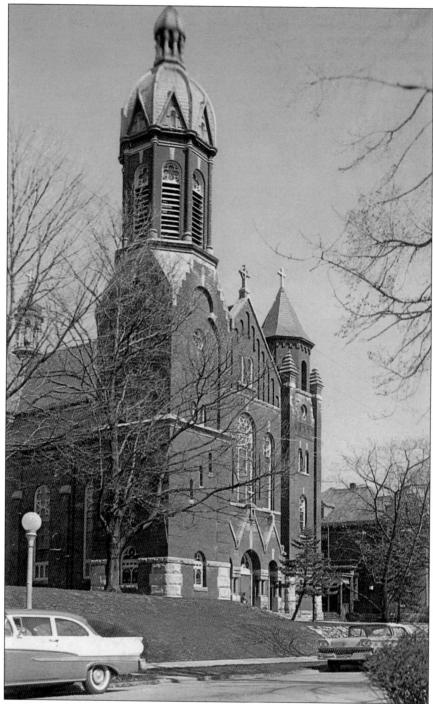

While Bridget Roche paid for St. Mary's Church and its furnishings, the members of the parish raised money to build the rectory and a school, which still serves the parish. The magnificent church is constructed in a Roman basilica style using red, polished brick. The ceiling is 57 feet high, and eight columns of Italian granite support the arches in the nave. The Stations of the Cross were imported from France.

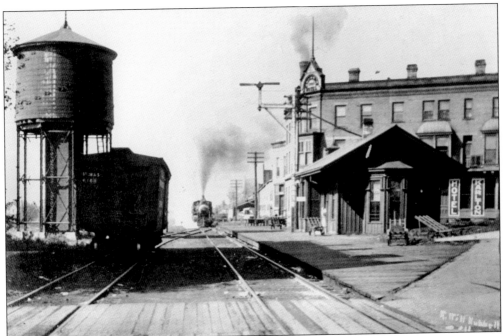

Here, a steam engine approaches the Jefferson Street intersection from the west in 1911. In the right background is the Flatiron Block, where one can see the placards for the Hotel Karlton. To the left is the railroad water tower, and to the center right is the old wooden Wabash passenger depot, which was later replaced with a brick structure.

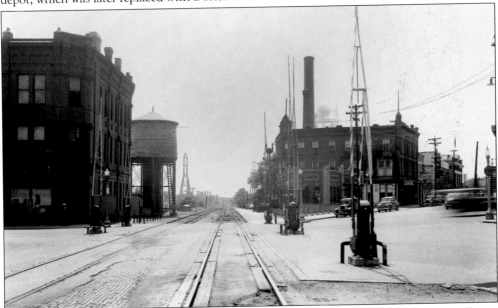

As in the photograph above, this shot is facing west along the Wabash Railroad at the Jefferson Street intersection, but this time in the 1940s. It depicts the brick passenger depot that replaced the old wooden depot. On the left is the Milligan Building, with the water tower in the background. The Flatiron Block is still behind the depot in this image. It has since been razed, and the space is now used for parking.

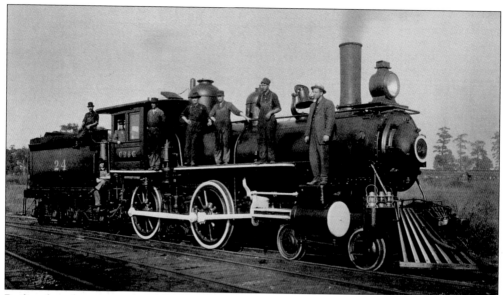

Railroad workers pose on a steam engine and its coal tender on the Cincinnati, Bluffton & Chicago Railroad (CB&C). The CB&C's checkered history reflects the boom-and-bust character of the railroading industry. Investors envisioned a rail line from Cincinnati to Chicago through eastern Indiana, but the only portion actually constructed ran from Portland to Huntington. The railroad opened for business in 1903.

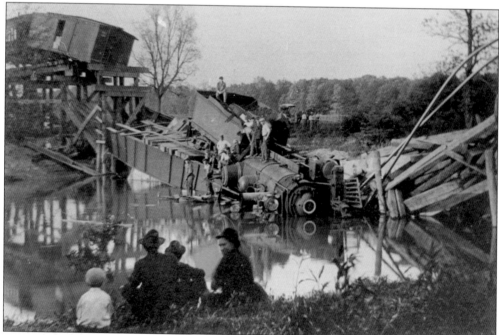

On May 22, 1913, this CB&C train plunged into the Wabash River just north of Bluffton, Indiana, when the flood-weakened bridge gave way. The train included the locomotive, two boxcars, and a wooden combine on the rear, and it was pushing five cars loaded with stone from the Erie Stone Company, east of Huntington. After being removed from the wreckage, the engineer, Adam Handwork, died while in transit to Huntington.

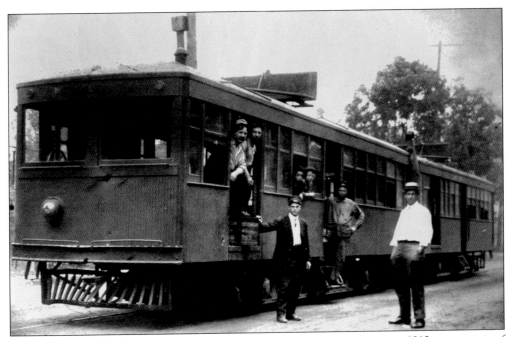

Part of the CB&C, this gasoline-powered motorcar was put into service in 1913 as a means of replacing older steam-powered engines. While some steam engines were still used on occasional runs, the smaller gasoline-powered cars, aided by the extension of the tracks closer to the business district of Huntington, allowed the line to save passengers a mile's walk.

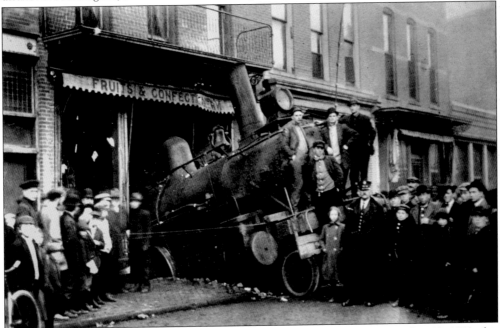

After being left at the coal dock with its fires banked for the night on December 13, 1913, this CB&C engine slipped from its moorings around midnight. After gathering speed for about six blocks, it finally ran off the end of the tracks and crashed into Mayne's Grocery. No one was injured. After suffering numerous mishaps, the CB&C was terminated in 1917.

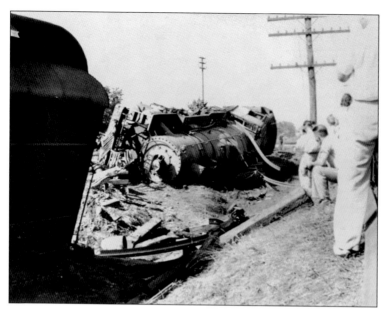

The summer of 1938 was a time of tragedy as a westbound Wabash Railroad train crashed into a pickup truck at the Jackson Street crossing. According to accounts of the wreck, the truck's engine lodged under a rail, causing the locomotive to derail and sending it end-over-end. While the driver of the truck miraculously survived, the engineer was scalded to death.

The employees of the Erie Railroad gathered together for a photograph in 1945. Huntington served as a location for crew changes and diesel service, so many staff members resided in town. The company went though many changes, but current residents know it as the Erie Lackawanna Railroad, which ran until 1976 when it was absorbed into Conrail. Ultimately, the tracks were removed, although the right-of-way is still visible.

Rollo Bigler stands in front of the railroad traffic control tower at the Jefferson Street crossing of the Wabash Railroad. The railroad transformed the landscape of Huntington, bisecting the city at several places and dotting it with passenger and freight stations, switching yards, signal towers, and crossing gates. These structures offered physical evidence of Huntington's progress in the industrial era.

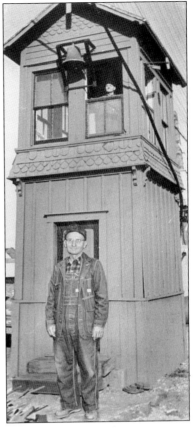

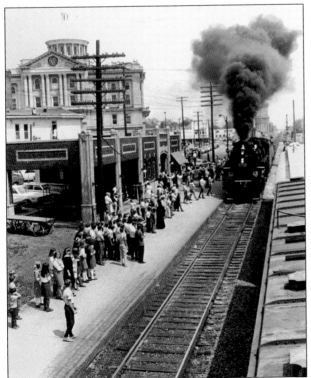

The Huntington depot of the Wabash Railroad hosts a crowd gathered to greet the Nickel Plate 759 in the early 1960s. Lima Locomotive Works of Lima, Ohio, built 80 of these steam engines between 1934 and 1949, which formed a class of Berkshire-type steam engines designed specifically to improve speeds of freight trains through the Nickel Plate system of rail lines in the Midwest.

This 1911 photograph shows the corner of Charles Street and Etna Avenue in the Drover Town district. Today, several businesses occupy the space, including Community Link Federal Credit Union and Sunshine Auto Sales. The Drover Town neighborhood is anchored by St. Peter's First Community Church (not pictured), which began as the German Reformed Church and constructed its current building in 1904 on the block formed by Etna Avenue and Charles and Henry Streets.

The North Jefferson Street Historic District, listed in the National Register of Historic Places, contains buildings like the A.J. Eisenhauer House, seen here in an undated photograph. The residence at 1019 Poplar Street was constructed in 1892 in the Queen Anne style and is in a neighborhood with houses displaying a variety of architectural styles, including Colonial Revival, American Four Square, Prairie, Victorian Gothic, and Italianate, to name a few.

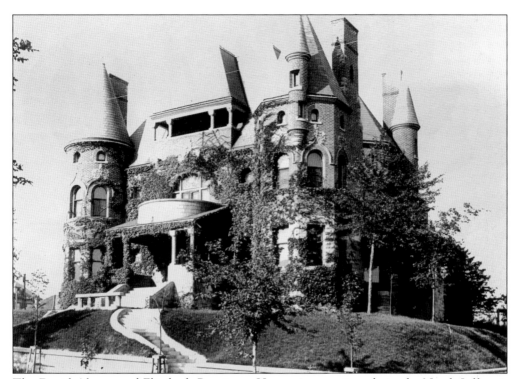

The David Alonzo and Elizabeth Purviance House sits prominently in the North Jefferson Historic District. It was built in 1892 during the late Victorian era of domestic architecture, and it combines elements of Chateauesque and Romanesque styles. It is considered one of the city's important early buildings; in 1994, it was included as one of the 19 Huntington County properties and districts in the National Register of Historic Places.

Erected in 1898 by Enos Taylor, the son of a cobbler who made it good, the Taylor-Zent House is an example of Romanesque Revival architecture. One of the most impressive homes in Huntington, the 14-room mansion was constructed with bricks imported from Italy, and the piano that graced the third-floor ballroom had to be lifted by crane before the structure was enclosed. The building is now the McElhaney-Hart Funeral Home. (Photograph by Jeffrey Webb.)

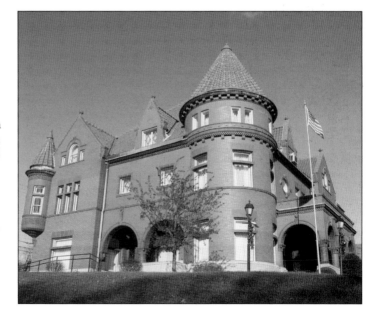

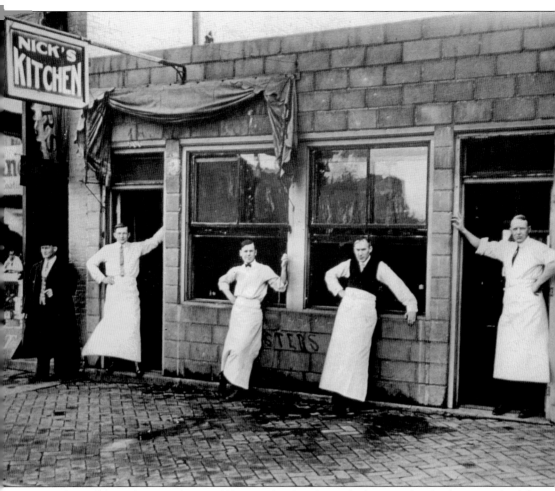

Nicholas Frienstien started out peddling sandwiches from a basket. He then built a cart, which he set up on the corner of Jefferson and Market Streets. He eventually moved to the location shown here in 1908, where the restaurant is still in operation. Although Frienstien sold his business in the late 1930s, the restaurant, Nick's Kitchen, still bears his name.

The City Meat Market, like many butcher shops of the early 1900s, depended on selling its products quickly. The advent of refrigeration meant people could keep meat longer, but it also meant that it was easier to transport. Local butchers often went out of business because larger packaging plants could supply the more diversified supermarkets with meat. The Meat Shop, on Etna Avenue, currently serves fresh meats to Huntington residents.

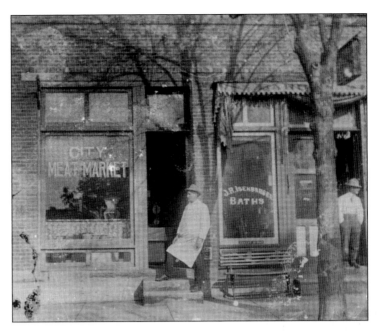

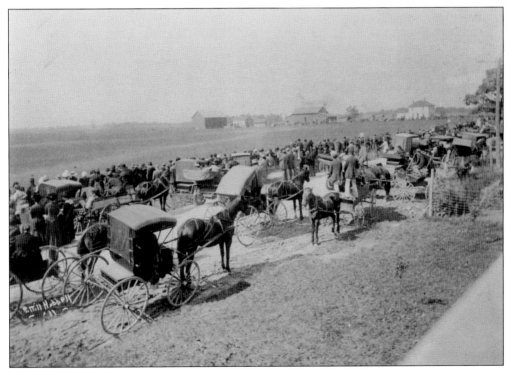

This crowd gathered at the Gorman farm in September 1911 to see the *Vin Fiz Flyer*, an early Wright Brothers Model EX pusher biplane and the first aircraft to fly coast to coast across the United States. The pilot, Calbraith Rodgers, used the route of the Erie Railroad tracks for navigation, performing the feat for a prize of $50,000 offered by William Randolph Hearst.

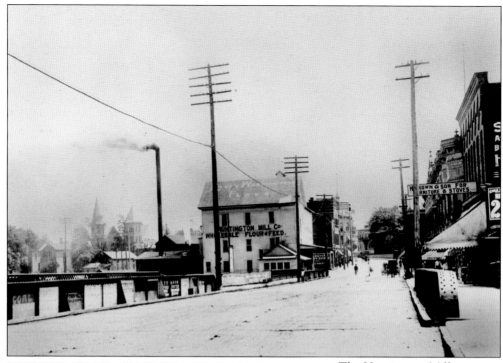

The Huntington Mill, shown here in 1902, was built by James Taylor on the Little River, which flows through Huntington. It was constructed at a cost of $15,000 and opened for business in November 1861. The flour produced by Taylor was called la Belle Langtry, most likely after famous English actress Lillie Langtry.

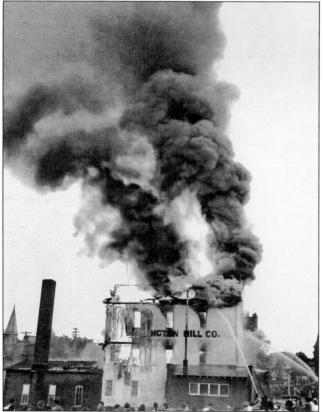

Taylor sold the Huntington Mill to Jesse Arnold and Enoch Thomas. Isaac Arnold then took charge of it in 1875, when it became known as Arnold's Mill and the flour was called Lady Washington. Arnold sold the mill in 1905, and it burned on Memorial Day in 1939. The building was completely demolished, but the origin of the fire was never discovered.

# Three

# COMMERCE AND INDUSTRY

By the eve of World War I in 1914, Huntington possessed all the attributes of a permanent, well-established Midwestern town. In a book titled *History of Huntington County*, published that year, author Frank Sumner Bash measured the town's progress against conventional standards of the age, and he approved of what he saw. He noted six new public school buildings and a high school in the planning stages. The city had a new town hall, a new county courthouse, a new public library, and 20 miles of paved streets. A power company had electrified the city 15 years earlier and supplied residents with natural gas. Three steam railroads and one electric line served Huntington and maintained regular commerce with Fort Wayne and points west. Churches, fraternal societies, and numerous mercantile establishments combined to make Huntington, according to Bash, "one of the gem cities of the Wabash Valley."

Industrial expansion and then economic boom in the 1920s introduced manufacturing to Huntington. A wide range of companies appeared or moved into town amid increasing national demand for home appliances, automobiles and auto parts, construction materials, industrial machines, medical equipment, and a variety of other durable goods. As the manufacturing sector expanded, Huntington continued to serve as a center of transportation, with several regional trucking companies hiring hundreds of drivers and mechanics. Huntington's expanding workforce bought houses in new neighborhoods on the edges of town and shopped for clothes and other necessaries at Woolworth's, an indication of things to come as national retail chain stores moved in to challenge local merchants. Prosperity came to Huntington in the 1940s and 1950s, symbolized by the appearance of automobiles, movie theaters, and eventually a wide range of national retail stores. The postwar consumer society bloomed in full flower in Huntington, just as it did all over the nation.

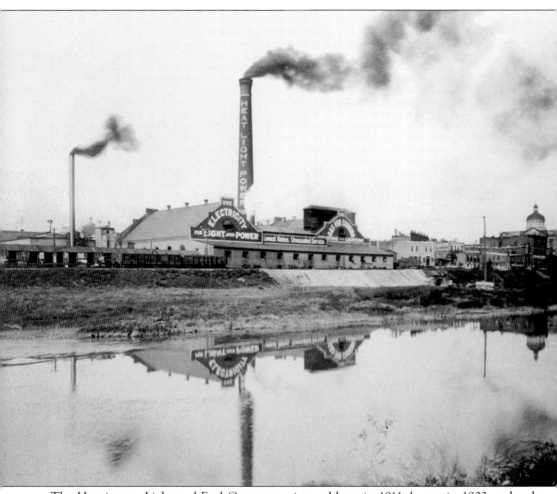

The Huntington Light and Fuel Company, pictured here in 1911, began in 1903 under the leadership of George Bippus. By 1906, it provided Huntington residents with electricity, coke, and petroleum. It also provided steam heating through a 20-block system of underground pipes. Within a few short years, manufacturers like Caswell-Runyan came to rely on cheap power from Huntington Light and Fuel, which served to expand the manufacturing sector of the local economy. The plant was located on the banks of the Little River off of State Street, just west of the recently built courthouse (right).

Electrification came to Huntington around 1900. Here, workers install an electric transformer platform in 1915, an essential component of the electricity infrastructure for town residences, businesses, and public buildings. With electricity came all the benefits of the modern industrial and consumer economy, including interior electric illumination, refrigerators, and powered washing machines. Electrification enabled local manufacturing plants to conduct more reliable and cost-effective production schedules.

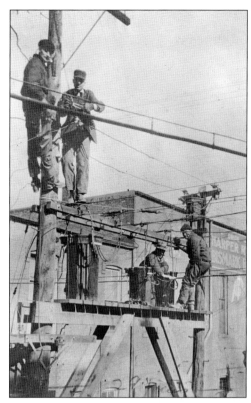

In 1923, Huntington's first electricity provider, the Huntington Light and Fuel Company, transferred ownership to the Northern Indiana Power Company. This photograph from the late 1940s portrays the power company's showroom, which marketed an image of the ideal modern American household complete with warming pads, electric irons, lamps, and of course an electric range. Electrical appliances replaced the old gaslights and firewood stoves of an earlier era.

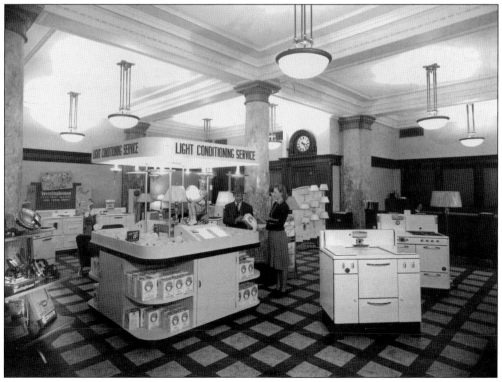

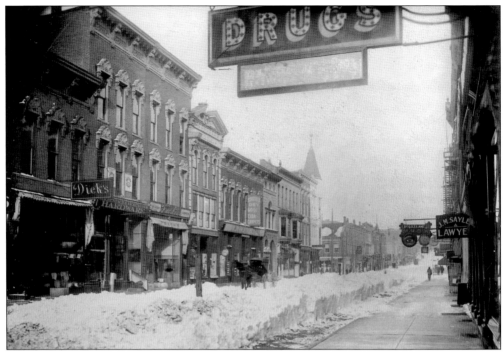

In early 1912, the Midwest experienced one of the worst cold and snow spells on record. The daily average low temperature in Indianapolis from January 5 to February 16 was -6 degrees. In Huntington, a foot of snow fell on February 2, which is seen in this photograph of Jefferson Street between Franklin and Market Streets. Without modern snow removal equipment, horses, buggies, and pedestrians were left to contend with the elements.

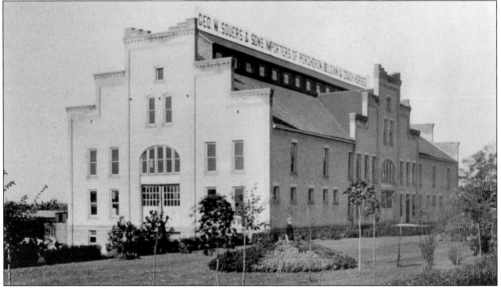

The stables of George W. Souers & Sons, pictured here in 1911, were practically unrivaled around 1900. George Souers, an expert horseman in his own right, imported Percheron, Belgian, and Coach horses from Europe, and he spared no expense in their care. Unfortunately, a lost shipment of horses during World War I created financial difficulties for his business.

Originally established in Lafayette, Indiana, Barker, Brown Company Shoes moved to Huntington around 1896. Although trade extended throughout the northern United States, most sales were concentrated in Ohio, Pennsylvania, and New York. By 1911, J.M. Barker was taking bids to construct a three-story factory with a basement at the site shown here in 1941, the corner of Salamonie and Joe Streets.

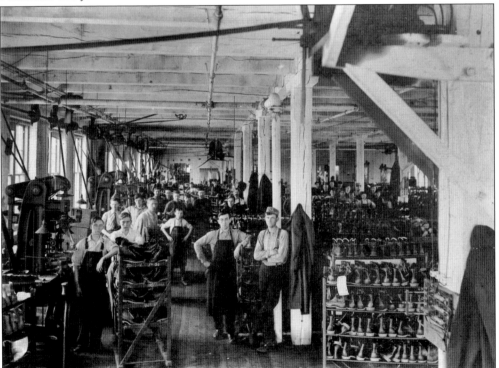

This photograph, taken around 1915, shows the production and distribution floor of Barker, Brown Company Shoes. An advertisement from that year touts, "'Rough-Wear' Boys' Shoes are built strong to last long. . . . The Barker Boys' Shoe has made good. It has established its reputation and it will establish yours."

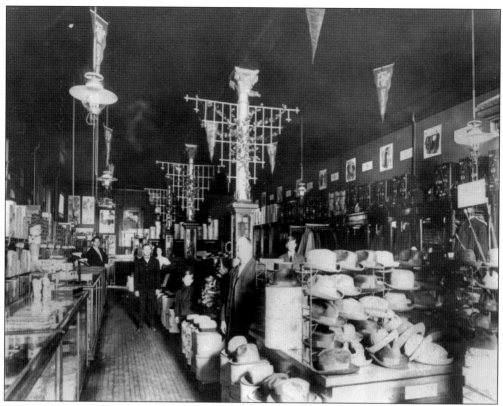

A businessman in Huntington who needed a new hat or suit jacket could find everything he needed at Frank Felter's Men's Store, located near Jefferson and Franklin Streets. Among the men pictured here in 1911 are proprietor Frank Felter and Theodore Finley.

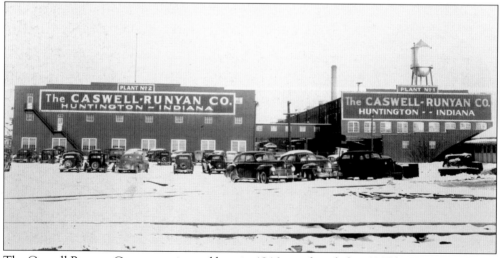

The Caswell-Runyan Company, pictured here in 1946, was founded in 1907 by J.W. Caswell and Winifred Runyan to manufacture cedar chests. Later, the company diversified its products to include radio and television cabinets. In 1929, Caswell-Runyan merged with a loudspeaker manufacturer, Utah Radio Products out of Chicago, and it was eventually acquired by the Merritt, Chapman & Scott Corporation, which liquidated the inventory and machinery in 1956.

Middle-class prosperity in the 1920s generated demand for merchandise across a broad range of product types. E. Murphy Webb's jewelry and watch store at 410 North Jefferson Street, pictured here in 1940, opened in 1932 and helped consumers gain entry into the market for luxury items by offering consumer credit, which had appeared with increasing frequency in the American economy in the interwar years. The store closed in 1985 after 53 years of operation.

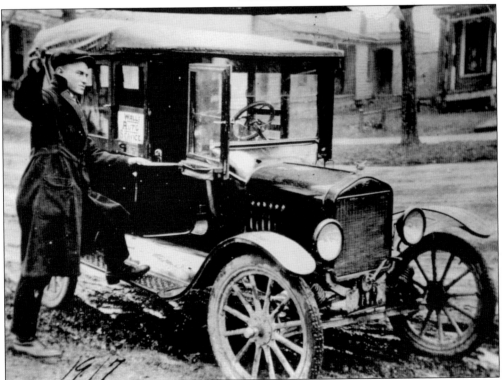

The Ford Model T came to Huntington during World War I, as shown in this 1917 photograph of a vehicle from Wall's Auto Service. The famous "Tin Lizzie" transformed manufacturing with the use of assembly line techniques to speed up production and reduce costs. This made the car affordable for middle-class families, which revolutionized consumer society in the United States. Some 15 million Model Ts were made between 1908 and 1927.

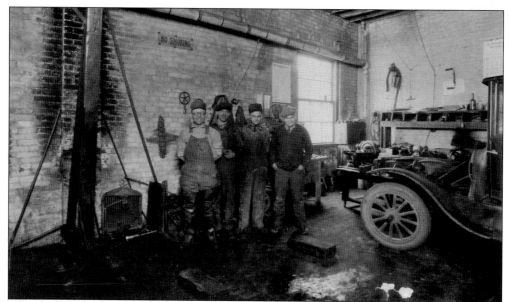

Taken between 1924 and 1928, this photograph of the interior of the Bonebrake Garage highlights the communal nature of local businesses in a small town. According to an inscription on the photograph, those pictured are "Esser Kitt who lived in Andrews and worked at Kitchen Maid, Harvey Cone who owned a grocery store on Briant Street, Floyd Maurer who sold oil products, and Ray Stults who worked at the garage."

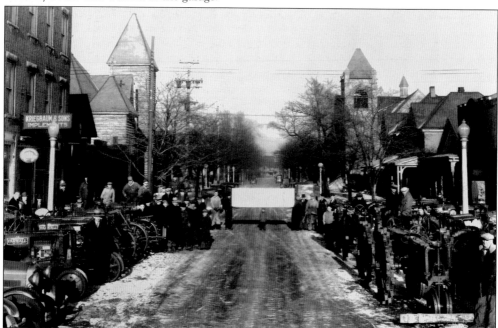

Kriegbaum & Sons Implements employees posed for this photograph in the 1930s. In 1886, John P. Kriegbaum established a hardware store along the old canal, which he moved to a new building on Franklin Street in 1906. In 1927, Kriegbaum donated the land for Kriegbaum Field, which serves as the football and track facility for Huntington North High School. Kriegbaum & Sons continued for many years until closing in 1975.

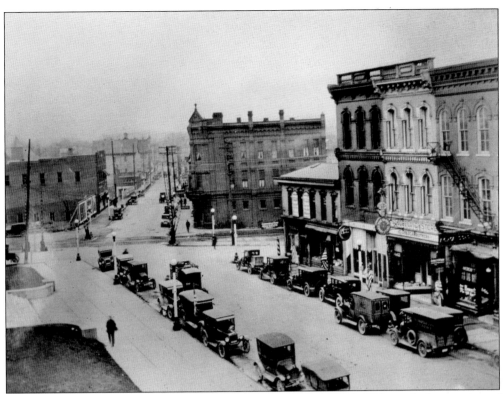

Courthouse Square took on a new appearance in the 1910s and 1920s with the coming of automobiles. This view on Courthouse Square shows more than a dozen Ford Model Ts parked along Jefferson Street. The Milligan Building can be seen across the Wabash Railroad in the center. Just as railroads had for canals in the 19th century, automobiles presented a challenge to railroads in the early 20th century.

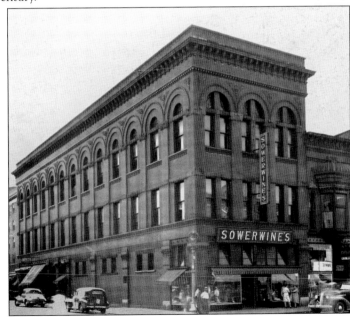

C.W. Sowerwine originally opened a dry goods store in Noblesville, Indiana. Then, in the late 1910s, he opened a store in Huntington on the corner of Franklin and Jefferson Streets, shown here in 1934. An aggressive merchant, Sowerwine recognized the value of attractive window displays to help sell his merchandise, including Edison phonographs. In 1920, his Huntington store won a display contest recognized at the New York Music Show.

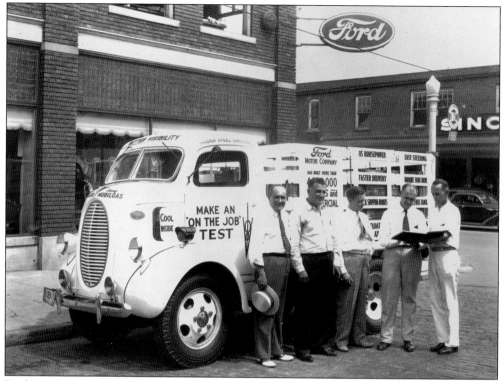

Ford Motor Company opened dealerships throughout the country in the 1920s, including the Ford Agency at Warren and East Park Drive, pictured here in 1938. The economic boom of the 1920s occasioned a dramatic expansion of consumer demand for durable goods, and retailers responded with installment plans and delivery services. This truck, a 1938 Ford COE (cab over engine), offered businesses a versatile and rugged delivery vehicle to serve their customers.

Huntington's car and truck buyers of the 1940s and 1950s patronized auto dealerships like Scherger Chevrolet, pictured here in 1953. Scherger's subsequently moved locations to North Jefferson Street near Kriegbaum Field and was followed by Pace Chevrolet, which opened in 1992 at its location on Hauenstein Road, and H.H. Niswander, which opened on North Jefferson and Home Streets.

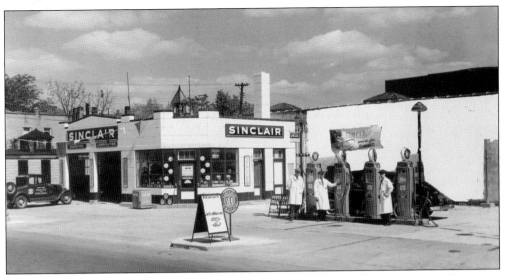

Sinclair Oil Corporation was founded in 1916 by Harry Sinclair and still has stations in 20 states in the West and Midwest. This Sinclair service station at the corner of East Park Drive and Warren Street, seen here around 1949, was operated by Milton Thrasher, who was also a part owner of the Northside Garage, whose logo appears on the car in front of the garage doors.

This Standard Oil station, seen around 1949, was operated by Charles Overly on East Tipton Street. Standard Oil was originally part of John D. Rockefeller's industrial empire until the government, citing the Sherman Antitrust Act, forced the company to divest itself of its major holdings in 1911. Several companies, however, retained Standard Oil in their names, including Standard Oil of Indiana, which later became Amoco and eventually merged with BP.

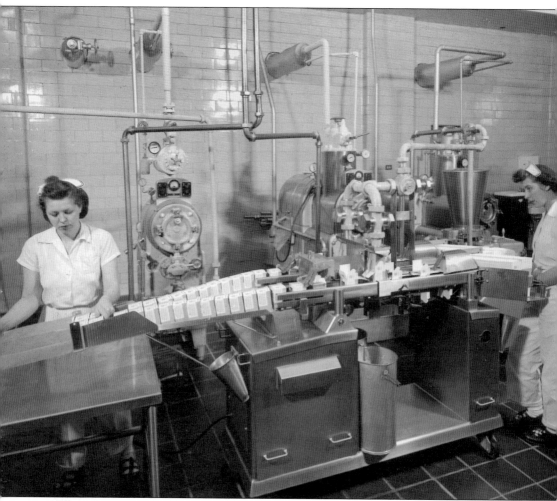

After starting a creamery in Markle, Indiana, E.L. Martin moved his business to Huntington around 1900. Later, in 1919, he officially established the Cloverleaf Creamery, and it became one of the top butter producers in the nation. Kraft-Phenix bought Cloverleaf in 1930, and the creamery eventually became a major producer of the brand Sealtest. This photograph is from 1950.

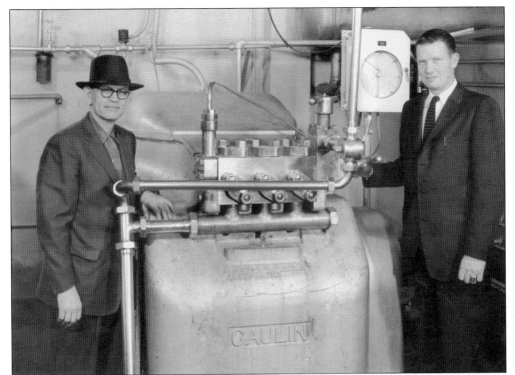

Showing off their new Manton-Gaulin homogenizer in 1957, these Cloverleaf Creamery employees were part of the ice cream boom that began in the 1940s. Because more grocery stores were expanding their stock to include frozen foods, Huntington continued to grow its facilities. In 1944, the Huntington plant became solely dedicated to producing ice cream.

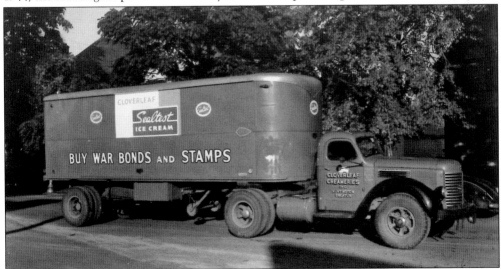

Kraft bought Cloverleaf Creamery and it became a subsidiary of the National Dairy Products Corporation; the Sealtest brand, shown on this truck in 1942, was established in 1934. The Huntington plant produced Sealtest until 1976, when it began producing Breyer's Ice Cream. Breyer's was bought by Unilever in 1993, and Huntington saw its long history of ice cream production end in July 2013 when Unilever shut down the Huntington plant.

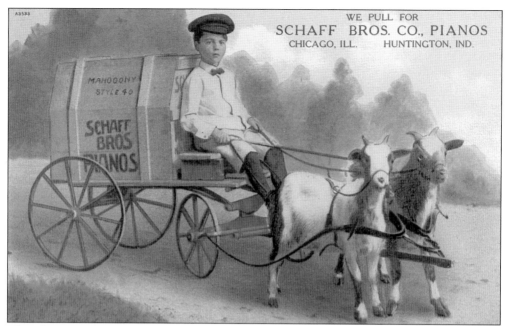

This advertisement promotes the famous Schaff Bros. Piano Company, established in Huntington in 1868. By 1900, the company built a full line of expensive, high-quality upright and player pianos. The pianos were known for their remarkable tone qualities and beautiful but durable construction.

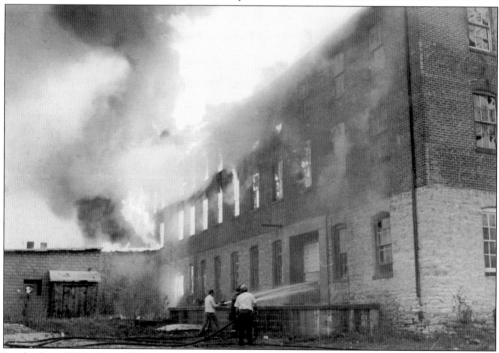

In the late 1920s, Schaff Bros. was bought by the Rudolph Wurlitzer Company, which helped pull the company through the Great Depression. Wurlitzer continued to produce pianos under the auspices of Schaff Bros. until the beginning of World War II. The factory where the pianos were produced burned down in the early 1950s.

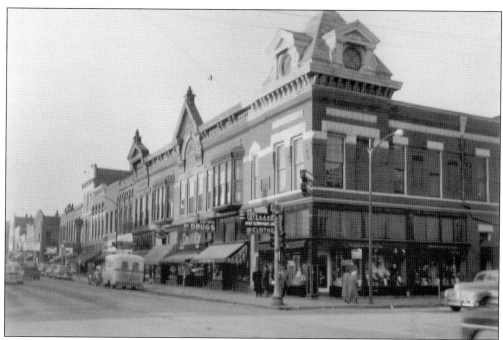

This view of Jefferson Street looking north from the Market Street intersection highlights the prominent location of Wissel's Clothes. This store outfitted Huntington's businessmen and professionals with the sales pitch "Clothes for men who care what they wear." Within a few years, the downtown district was completely transformed by city officials, who turned Jefferson into a one-way street and prepared the way for what locals called "The Mall." (Courtesy of United Brethren Historical Center.)

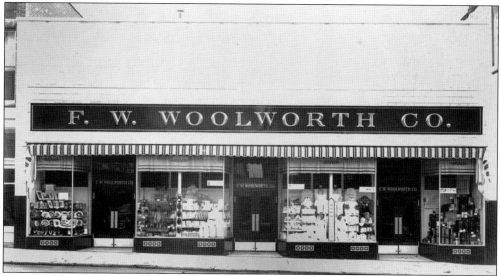

Although his first store in New York failed in 1879, Frank W. Woolworth maintained that selling a variety of inexpensive items would bring customers. He was right. By World War I, Woolworth's was a nationally recognized department store. Despite Woolworth's own humble beginnings, many locals resented the chain store, fearing it would drive many local merchants out of business. This storefront, seen around 1941, was located in downtown Huntington.

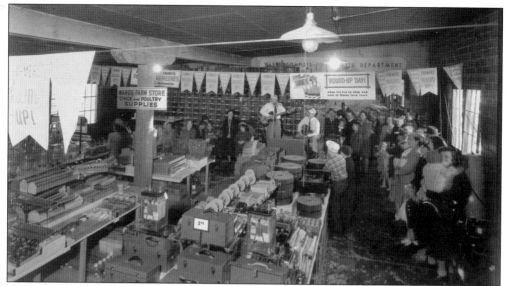

Celebrating its "Round Up Day" around 1945, the Montgomery Ward Farm Store in Huntington draws in customers. Begun as a mail-order business in 1872, Montgomery Ward & Company began establishing retail stores in 1926. By 1985, the company discontinued its catalog business, and increased competition from "superstores" led to the company's bankruptcy in 1997. Interestingly, the Montgomery Ward name is once again associated with its catalog, which was reestablished online in 2008.

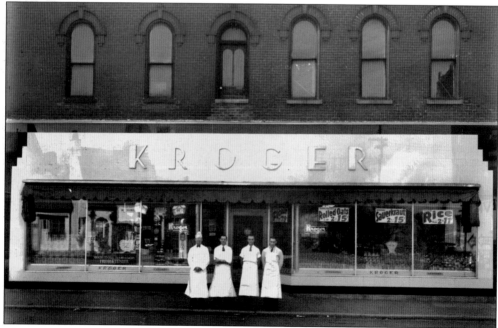

The Kroger Grocery and Baking Company was established in 1883 by Barney Kroger in Cincinnati. While other grocers bought their bread from independent bakeries, Kroger determined in 1901 that he could save his customers money by baking his own bread. By 1930, Kroger was the second-largest chain grocery store in the United States. Although no longer at the Jefferson Street location seen here in 1941, Kroger still has a presence in Huntington.

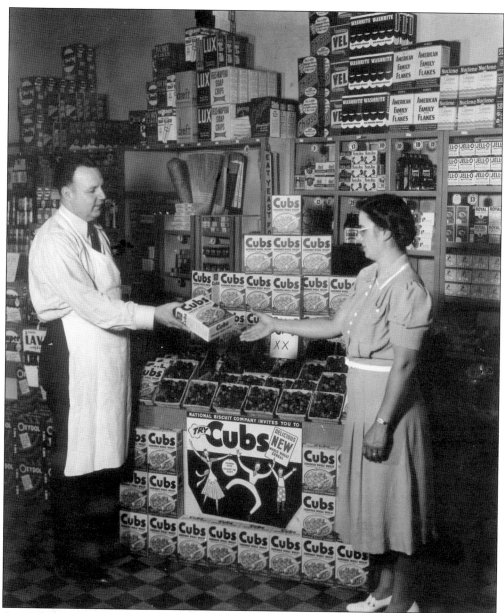

Around 1941, the manager of Central Home Grocery encourages a customer to try Cubs cereal, the predecessor to Shredded Wheat. Henry Perky, who invented the cereal by cooking, drying, and then stacking the webs of wheat, sold his company to the National Biscuit Company (now Nabisco) in 1904. When Kellogg's began producing a similar product, Nabisco sued, but the patent had expired, and "shredded wheat" was determined to be a term that could not be trademarked.

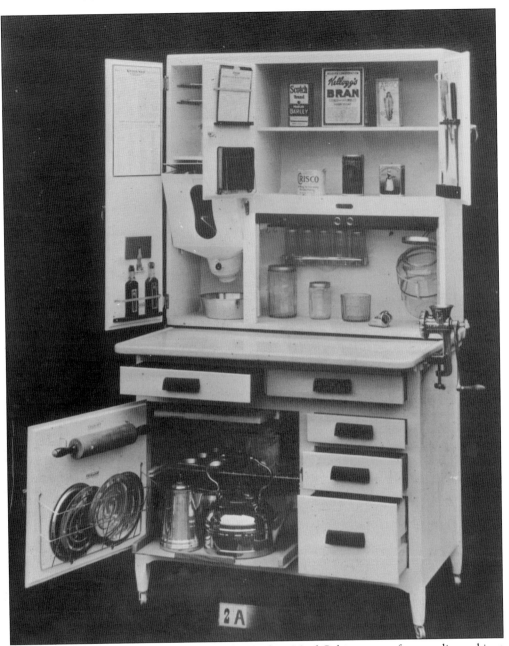

Designed to be an "all in one" workspace, the Kitchen Maid Cabinet was a freestanding cabinet that was supposed to bring beauty and practicality to the kitchen. Attributed to Friedemir Poggenpohl, a German cabinetmaker, "The Ideal" prototype, on which the Kitchen Maid brand was based, was licensed by Wasmuth-Endicott Indiana, which produced Hoosier Cabinets, branded as Kitchen Maid.

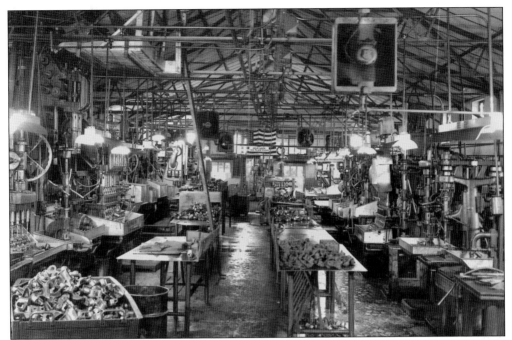

The Schacht Rubber Manufacturing Company began in the 1910s after its founder, William F. Schacht, moved into Huntington from Elkhart, Indiana. He was employed as a salesman for a rubber products company and soon got the idea to begin his own manufacturing firm. Beginning with just three employees, Schacht Rubber grew to 170 by the mid-1920s. Some of the machines that made Schacht rubber products are seen in this 1943 photograph.

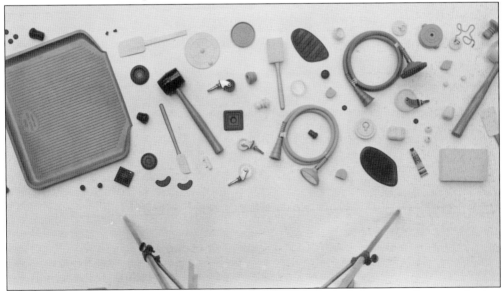

The Schacht Rubber Manufacturing Company's products included pump valves, crutch tips, soap dishes, mason jar rings, mallets, caster wheels, shower hoses, and myriad other items. This 1948 photograph shows several of the famous "Daisy" spatulas found in most postwar American kitchens. Millions of Americans read the words "Huntington Indiana" stamped on the handle as they prepared dinner and washed dishes.

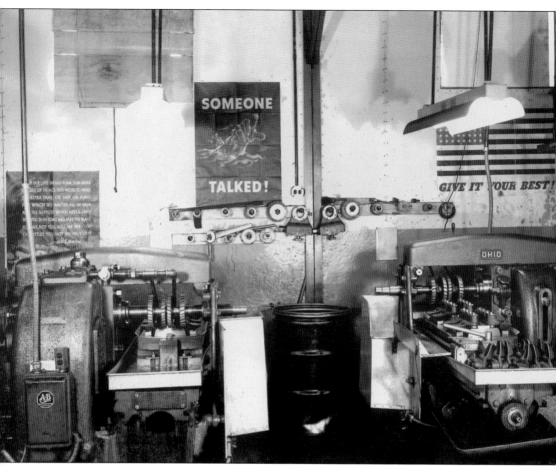

In 1943, Schacht Rubber Manufacturing Company, like many other industries, was swept up in the war effort. President Roosevelt's cost-plus defense contracts ensured profits for large corporations, triggering a dramatic expansion of the economy's manufacturing sector. In this image from 1943, a poster encourages workers to keep making supplies, with this US Marine warning: "We, not you, will pay the cost of battles you, not we, have lost."

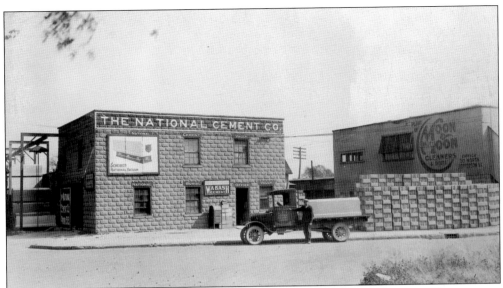

In this 1920s photograph, workers pose in front of the National Cement Company. The company was known locally for its Scheiber National Vacuum Vault, which promised a watertight burial vault impervious to harsh underground conditions. In 1988, the Byron Street building was purchased by the Wilson Burial Vault Company, but in 1999 the expanding business moved its operations to the former Millington Truck Body building on Markle Road.

The Western Rock Wool Corporation Plant, located on Broadway Street, produced insulation for building construction. This photograph shows the plant in 1945. After World War II, Congress enacted the GI Bill that offered veterans low-cost home mortgages and sparked a nationwide frenzy of new home construction. Companies like Western Rock Wool benefited greatly from the new demand for building materials.

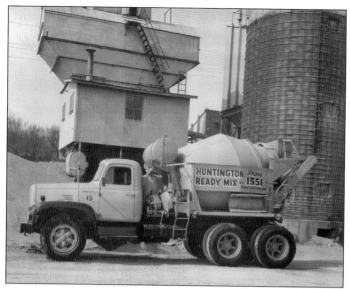

Belonging to Ready-Mixed Concrete Manufacturers, Huntington Ready Mix has been locally owned and operated since 1958. It expanded its enterprise by acquiring market shares in the surrounding area, including Columbia City (1960s), Wabash (1975), and Peru (1985). The company takes pride in investing in communities to make them better places to live and work.

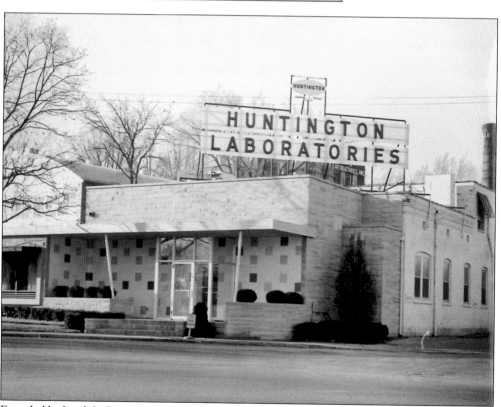

Founded by Jacob L. Brenn in 1919, Huntington Laboratories was managed for many years by his son Earl Brenn, a prominent member of the Fort Wayne synagogue Temple Achduth Vesholom. A generous donation from the Brenn family made it possible for Huntington College to construct its first building, dedicated to the study of the sciences. In 1996, Huntington Laboratories became part of Ecolab, a leading developer of sanitation and hygiene technologies. (Courtesy of United Brethren Historical Center.)

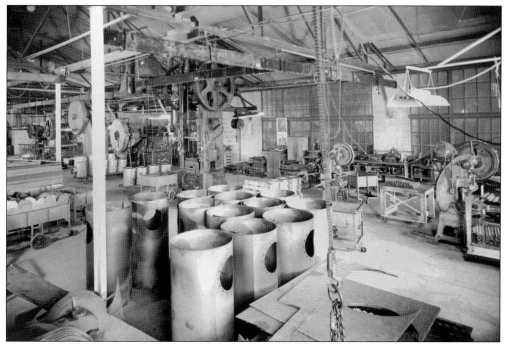

The furnace production area shown here in 1949 is part of the Majestic Company, which was established in Huntington in 1907 by Michigan native J.M. Triggs. Majestic focused on producing furnaces and coal chutes, but it also added other products over time. In 1942, a division of the company was set up to produce aluminum aircraft castings for the war effort. Majestic merged with American Standard in 1969.

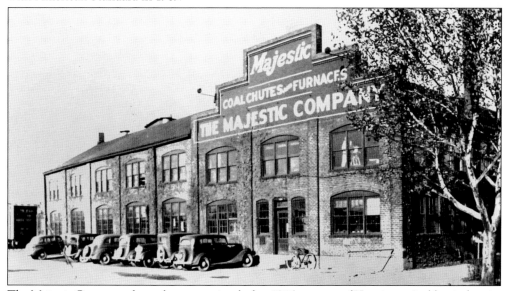

The Majestic Company, shown here sometime before 1946, was one of Huntington's oldest industries and top employers until it filed for bankruptcy in 2008. Majestic was purchased by Canadian Fireplace Manufacturers Limited (CFM) in the late 1990s, but mismanagement eventually ruined the company. Onward Manufacturing Company, a Canadian company that makes outdoor grilling products, took over the building in 2010.

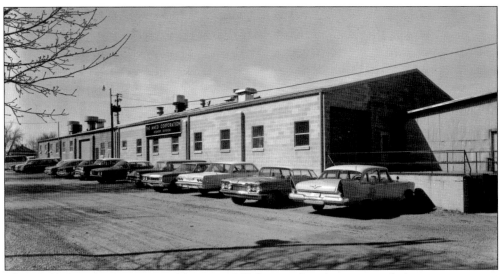

The Maco Corporation, pictured here in 1967, has produced commercial aluminum castings since 1946, when it was created from the aluminum division of the Majestic Corporation. Its expansion at its location at Henry and Gardendale Streets signaled the increasing importance of manufacturing to Huntington's local economy, as well as its growing connection to the rapidly developing American automobile industry.

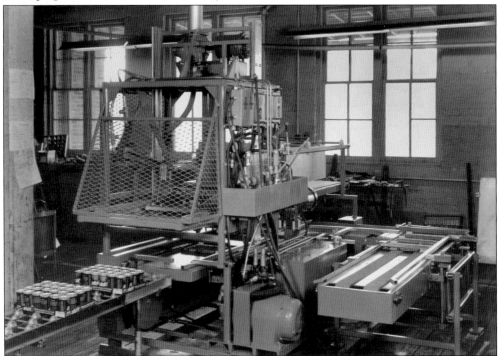

This photograph from 1966 reveals an interior view of the Shuttleworth Machinery Corporation located on Salamonie Avenue. In the late 1930s, Charles Shuttleworth and his son Jim developed a "Can Unscrambler," a machine to assist in the process of canning tomatoes. In 1962, Shuttleworth Machinery Corporation expanded on this concept and began marketing industrial packing and handling machinery for a wide variety of industries.

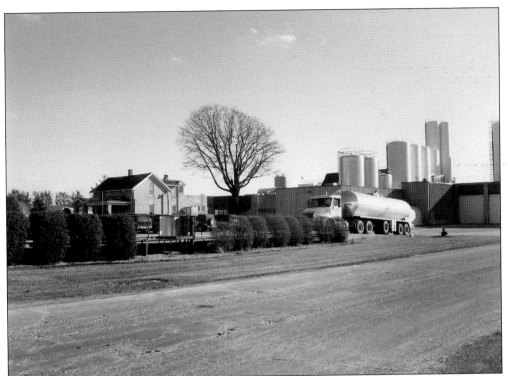

Schenkel's Dairy is located near the intersection of Flaxmill Road and Route 24. The business was started by Alvin Schenkel with two cows named Bessie and Mousie on Maple Grove Road near Andrews. Operations relocated to Flaxmill in 1940, and pasteurizing machines came soon after. Over time, consolidation has made Schenkel's, now part of Dean Foods, the only dairy in the county, where at one point 21 dairies once stood. (Photograph by Jeffrey Webb.)

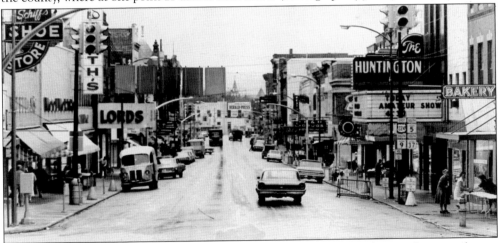

The Huntington (right) still retains its iconic marquee. It served as the town's movie theater until 1999 and is currently home to the Huntington Supper Club. At the end of the street is the Herald-Press Building, the home of the local newspaper. In the 1960s, when this photograph was taken, the *Herald-Press* was owned by James C. Quayle, the father of former vice president Dan Quayle. The Quayle family sold the newspaper to Paxton Media Group in 2007. (Courtesy of United Brethren Historical Center.)

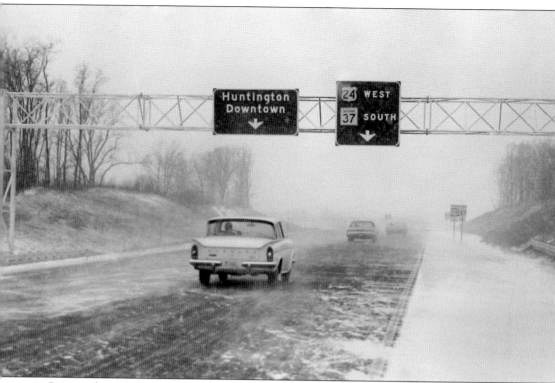

Cutting through the north-central part of Indiana, US Route 24 was one of the original US highways established in 1926. Initially following the same path as the Wabash and Erie Canal, Route 24 ran through downtown Huntington. After its completion, the Route 24 bypass, shown here around the time it opened in 1968, created an economic shift from the downtown area toward the north of town. (Courtesy of United Brethren Historical Center.)

# Four

# PUBLIC LIFE

Huntington's landscape reflects its long history as a market town and a center of local government. Jefferson Street, Huntington's main street, forms a long north-south axis bisecting the railroad tracks and the Little River, which run parallel to one another from the east end of town to the west. At this junction lies Courthouse Square, framed by Jefferson, Franklin, Warren, and Court Streets, where generations of county and town residents traveled to conduct business, pay taxes and fines, and celebrate holidays. Courthouse Square attracted law firms, title companies, insurance agencies, and banks. A few streets over, Huntington's mayor and city council addressed, and still address, the needs of a growing community from their offices in the City Building, voting in measures for police and fire protection, street building and repair, waste water treatment, zoning and environmental regulation, and hundreds of other matters of local concern.

In keeping with this public-spiritedness, Huntington residents have served in all of America's wars of the 20th and 21st centuries. Residents sacrificed for the Union during the Civil War, although at least one local, Lambdin P. Milligan, supported the Confederacy—and even became the subject of an important Supreme Court decision. World Wars I and II came to Huntington, when young men and women went off to serve in distant places and factories at home mobilized for wartime production. The town's civic spirit motivated one resident, Dan Quayle, to become a US senator and ultimately the 44th vice president of the United States.

Huntington's public spaces are an arena for picnics, parades, historical reenactments, fairs, fireworks displays, and so on. Places like the Sunken Gardens, Memorial Park, Yeoman Park, Lake Clare, and Hier's Park provide the community with stages for a succession of annual observances like Huntington Heritage Days, the Pioneer Festival, and the 4-H Fair, maintaining a tradition of nearly two centuries of social interaction and celebration.

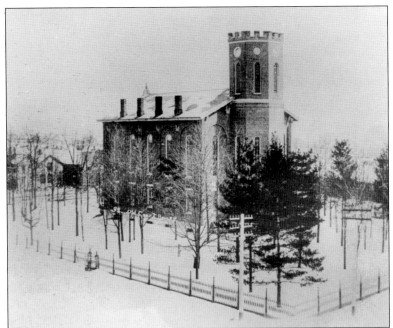

The original courthouse, most likely a wooden structure, was built on land donated by John Tipton on the northwest corner of Jefferson and Franklin Streets. In 1858, this new structure was erected on the present site. It was later torn down to make way for the current courthouse, whose cornerstone was laid in 1904.

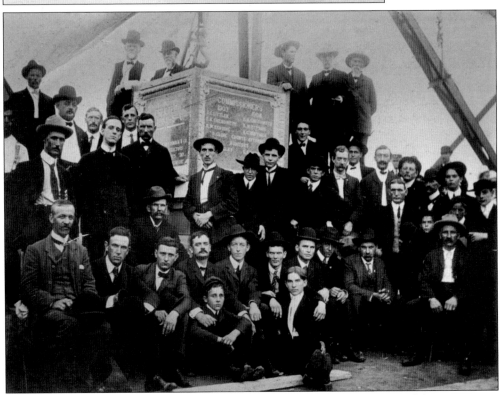

The Huntington County Commissioners of 1903–1904 gathered for the laying of the cornerstone of the present Huntington County Courthouse. The cornerstone, weighing five tons, was quarried in Redstone, Maine. The courthouse itself was designed by J.W. Gaddis of Vincennes in a Grecian architectural style and constructed primarily of Indiana Oolitic limestone.

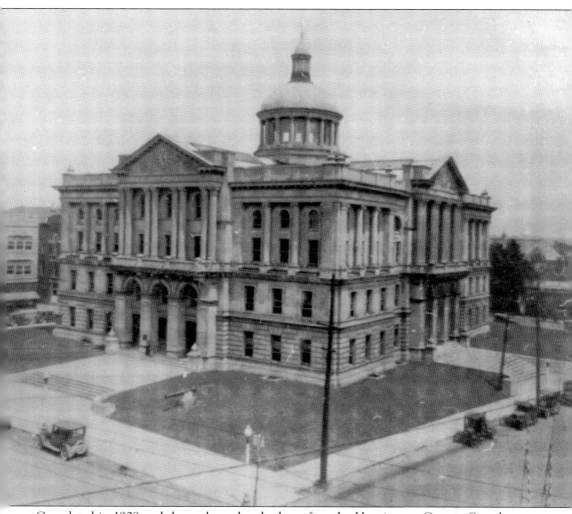

Completed in 1908 and shown here shortly thereafter, the Huntington County Courthouse remains a central and significant structure. Its neoclassical facades capture the high aspirations of the Huntington populace when the courthouse was built. The interior includes hand-painted murals, and the eagle mosaic in the center of the lobby floor was made with Italian tiles and installed by a Sicilian artist.

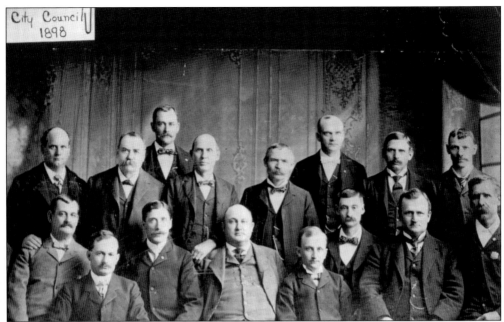

The members of the Huntington City Council are seated for a photograph in 1898. Huntington's mayor, Simeon T. Cast, was manager of the First National Bank. His relationship with the city council was turbulent; the council accused him of overstepping his authority when he tried to create a metropolitan police force. The dispute was the subject of a lawsuit that was ultimately decided by the Indiana Supreme Court.

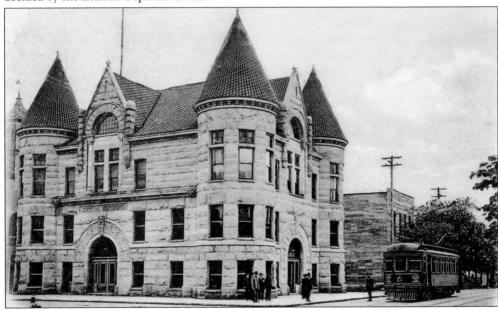

The City Building in Huntington, pictured here, opened in 1904. It was constructed with Bedford limestone at a cost of $30,000 and situated at the southwest corner of Cherry and Market Streets. The building housed the police department and the offices of the city clerk, engineer, mayor, and waterworks. City council meetings were held in the third-floor assembly hall, where they continue to meet in the present day.

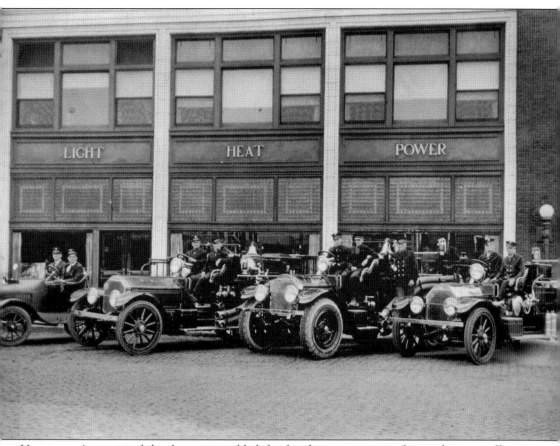

Huntington's municipal development enabled the fire department to professionalize its staff in the late 19th century and modernize its firefighting equipment in the early 20th century. In this photograph from the 1920s, the fire department displays its new fleet of Ford Model T fire trucks in front of the Northern Indiana Power Company building. The new fleet replaced horse-driven, steam-powered engines with internal-combustion engines.

This photograph shows the home of Gen. James R. Slack (1818–1881), who served in the Civil War. He became an attorney and then a state senator before receiving a commission as colonel of the 47th Indiana Volunteer Infantry in 1861. He served in the Army of the Mississippi in the Vicksburg and Red River Campaigns. After the war, he served as a circuit court judge in Indiana.

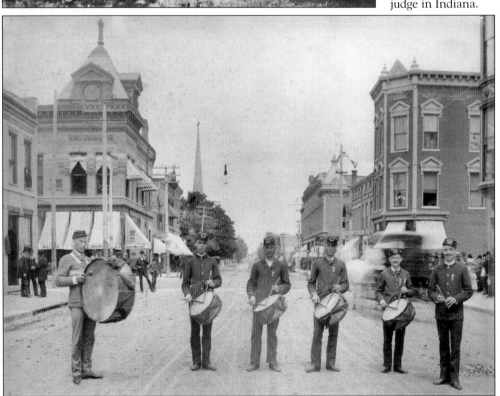

This 1890 photograph shows a drum corps wearing Grand Army of the Republic (GAR) uniforms at the corner of Jefferson and Market Streets. The GAR was formed in 1866 from all the Union Civil War units as a way to administer veterans' affairs. Dr. George McLin's office was in the building at right. Dr. McLin achieved fame with a medicinal tonic called Oil Radium and a popular beverage called Konatona.

Taken around 1899, this photograph shows members of the Hospital Corps serving at Camp Columbus, Cuba. John Kissinger (third row, far right) volunteered for the Spanish-American War, but a bad foot put him in the Hospital Corps with the 7th Cavalry in Cuba. In 1900, when Pres. William McKinley sent four doctors—including Dr. Walter Reed—to Camp Columbus to determine a cause for yellow fever, Kissinger volunteered to be infected.

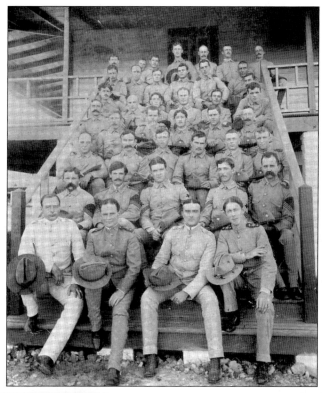

After voluntarily contracting yellow fever to determine its cause and cure, John Kissinger eventually recovered, but he suffered the effects for the rest of his life, at one point becoming an invalid having to crawl on his knees. Through sheer determination, he learned to walk again. He was awarded the Congressional Medal of Honor and presented with a home near Huntington, where this photograph, likely with Walter Reed's wife, Emilie, was taken.

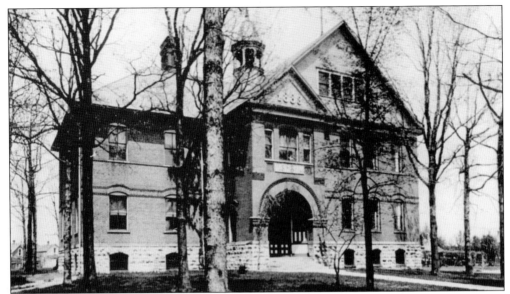

Huntington's pioneer children attended school in a log cabin on West State Street, the town's first school building. By 1900, the city had built six public schools: Huntington High School, Central School, William Street School, Tipton Street School, Allen Street School, and the one shown here, State Street School, constructed in 1883. In 2013, the countywide consolidated school system had an enrollment of 5,646 students.

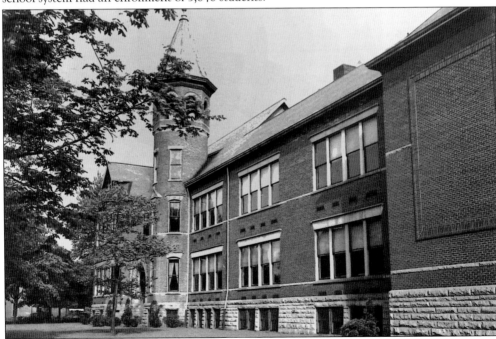

The original building of Horace Mann School, renamed from William Street School in 1926 after eight classrooms and a gymnasium were added, demonstrates a blend of Victorian Romanesque and Queen Anne architecture. Before the school was moved to a more modern building, Horace Mann, built in 1895, was the oldest extant school in Huntington, constructed on land donated in 1860 by Henry Drover.

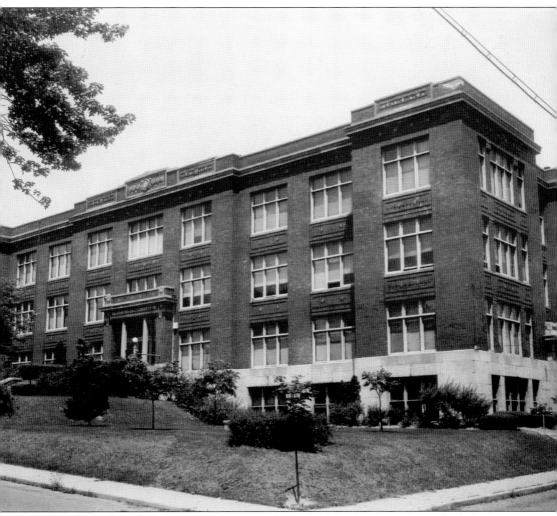

Huntington High School, built in 1917, was one of several high schools in Huntington County before they were consolidated into what is now Huntington North High School in 1969. Future vice president Dan Quayle graduated in 1965, just before the shift. The building became Crestview Middle School until it also moved to a new location in 1998, after which the building was demolished to make room for General Slack Park.

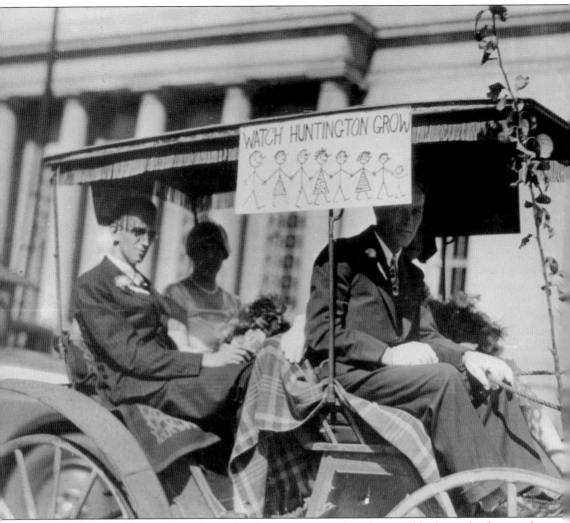

In 1911, Huntington's boosters staged a competition to identify a suitable slogan for the city that might express its aspirations for future growth and prosperity. This buggy features one of the entries, "Watch Huntington Grow." Other candidates for the city slogan included: "Hunting a Town, No Better Found," "Keep Behind the Gun; Boost Huntington," "Although Huntington Has No Parks, the People Are Just as Happy as Larks," "See Her Hum! She Wins, by Gum!" "Huntington Is to the State, What Frosting is to the Cake," "Me and My Gal for this 'Municipal'," "What Huntington Needs, Before It Leads, Is a Trolley; to Make Room for More of a Boom, Get a Trolley," "Huntington's a Daisy, Anything But Lazy," and "Huntington: Paradise of the West."

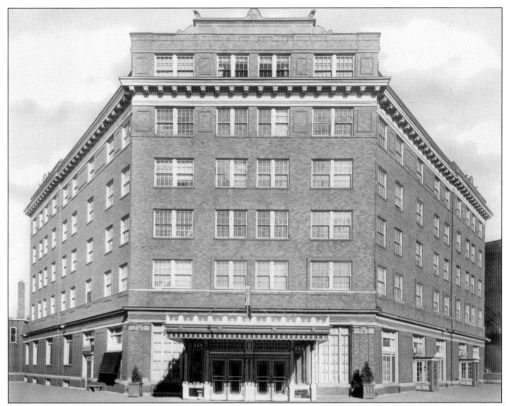

Known throughout the Midwest for its opulence, the Hotel LaFontaine, seen here in 1955, was opened in 1925 by James Bippus. The Depression forced Bippus to relinquish the hotel, and subsequent owners were unable to attract the wealthy clientele to maintain it. Closed in 1974 and falling into disrepair, the hotel was saved by citizens who applied for grants to convert the hotel into assisted-living apartments.

Now listed in the National Register of Historic Places, the Hotel LaFontaine was known for its luxurious rooms, world-class restaurant, and spectacular pool. This photograph of the art deco–style cocktail lounge provides a glimpse of the lavish interior that attracted such famous guests as Henry Ford, Amelia Earhart, Johnny Weissmuller (of Tarzan fame), and notorious gangster John Dillinger. Weissmuller, a five-time Olympic gold medalist, helped dedicate the pool, which featured four Egyptian tableaus.

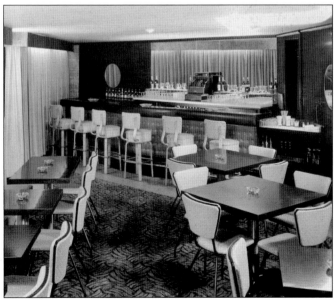

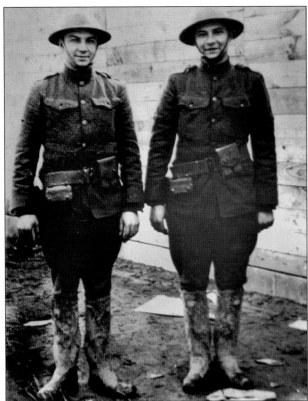

In April 1917, Pres. Woodrow Wilson asked Congress for a declaration of war against Germany. A law providing for a national draft came along six weeks later, and the draft lottery was held in Huntington on July 20, with some 2,432 county men eligible. The War Department fixed Huntington's quota at 176 men. This photograph from the period shows two unidentified area men who answered the nation's call.

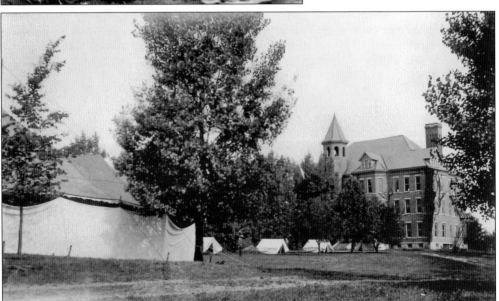

In 1918, Huntington College offered its facilities and faculty to the War Department as part of the Student Army Training Corps. Combining both military and academic instruction to men over the age of 18, the program trained men who agreed to enter into service in June of the following year. Many of the men were housed in government-issued tents on the college campus. (Courtesy of United Brethren Historical Center.)

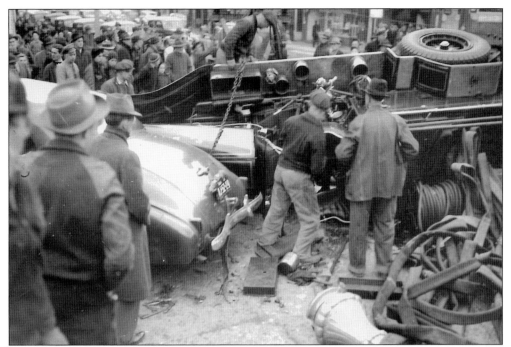

The corner of West Park and North Jefferson Streets was the site of a deadly crash on February 8, 1940, when a city fire truck collided with a car, killing three people. One of the occupants of the automobile died, as well as two of the firemen, Isaac Fisher and Harmon Rittenhouse.

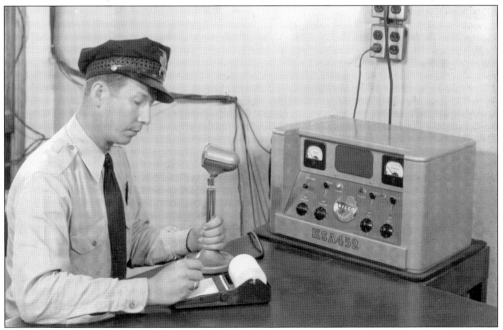

Bob Smith communicates with a patrol car from dispatch around 1949. The number on the radio, KSA452, is the call sign used by the Huntington Police. The FCC assigns licenses to public-safety entities for allotments of the radio spectrum, usually on the lower portion of the VHF spectrum. These are used by local and state police to run their own systems of communication.

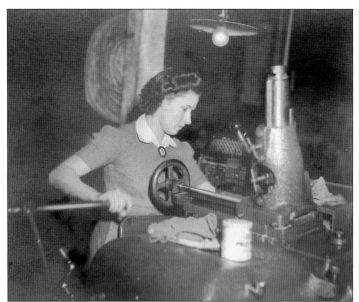

In this photograph from 1940, Millicent Kimmel operates a grinding machine as part of the process of fabricating 20-millimeter cannon ammunition at the Hosdreg Manufacturing Company. Many real-life "Rosie the Riveters" like Kimmel performed industrial work to support the war effort during World War II. After the war, Hosdreg converted from a munitions manufacturer to a chemical company that marketed modeling clay for children.

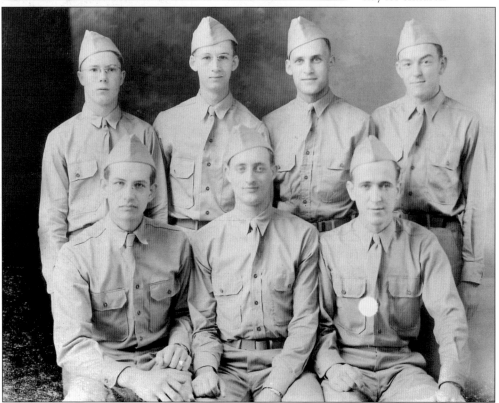

In the 1940s, facing rationing and shortages in services, communities throughout the Midwest still mobilized for war. In this photograph from 1943, students from Huntington College model their new uniforms following their enlistment in the armed forces. Carl Zurcher (second row, far right) went on to have a long career as a professor of speech and communication at Huntington College. (Courtesy of United Brethren Historical Center.)

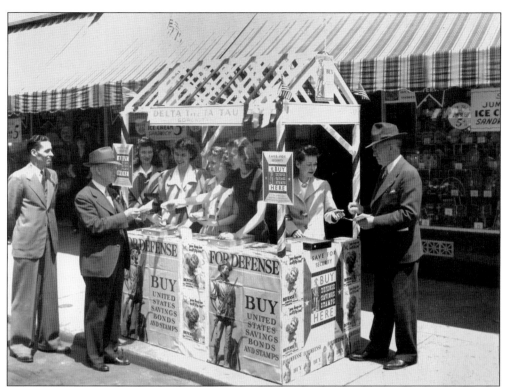

Members of the local chapter of Delta Theta Tau, a national philanthropic sorority, sell war bonds in front of the Woolworth's in downtown Huntington. In towns throughout the nation, social clubs and charitable organizations such as Delta Theta Tau joined national media campaigns with celebrities like Frank Sinatra, Bob Hope, and Marlene Dietrich to help the government secure the necessary funds to support the war effort.

Dale Pence was in his third year at Huntington College when he enlisted in the Army. A part of the 35th Division, he was on the 134th Infantry Regiment's championship basketball team before being sent overseas. Landing on Omaha Beach a month after D-Day, he was wounded in action twice, with the second injury leading to the amputation of his leg. He later returned to Huntington and completed his degree.

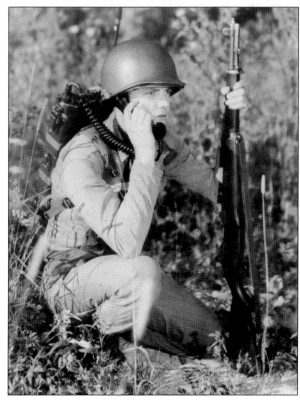

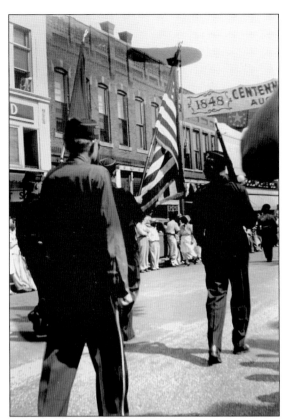

Organized by the Huntington Chamber of Commerce, which was founded in 1911 and incorporated in 1934, the centennial parade in 1948 was a huge success involving hundreds of citizens. Shown here are members of the local Veterans of Foreign Wars (VFW) post, chartered in 1932. The year after the parade, and for five consecutive years after, the VFW post drill team and firing squad were Indiana state blue-ribbon winners. The post continues to serve Huntington.

The Clark Twins participated in the Huntington centennial parade in August 1948. From Andrews, just outside of Huntington, the Clarks' parents had 11 children, including four sets of twins: six boys and two girls. The six boys won the National Family League basketball championship in 1946 and 1947, and they toured with the Harlem Globetrotters for four years.

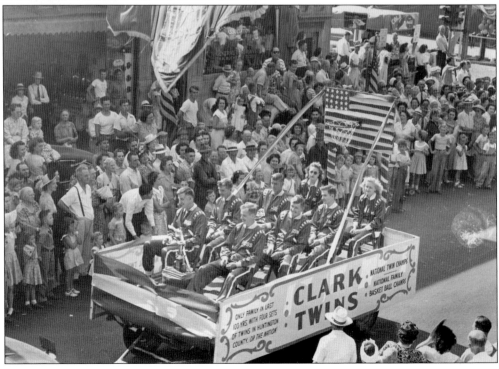

The Great Flood of March 1913 had a devastating impact on the entire state of Indiana. Floodwaters along the Wabash River reached anywhere from two to eight feet higher than any previously recorded flood. The river, which averages about 231 feet wide, swelled to seven miles wide in places. In this photograph, looking from Etna Avenue toward London Street, waters have covered several blocks beyond the riverbanks.

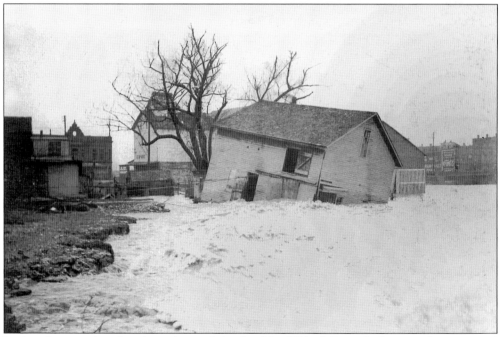

In this photograph, taken from the south bank of the Wabash River looking northwest toward downtown Huntington, one sees the raging currents resulting from the floodwaters of 1913. Entire neighborhoods and even acres of farmland were swept away. Transportation was halted, lines of communication were down, and the town was without power for several days.

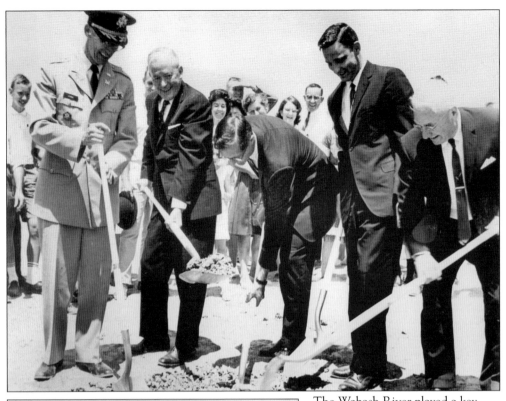

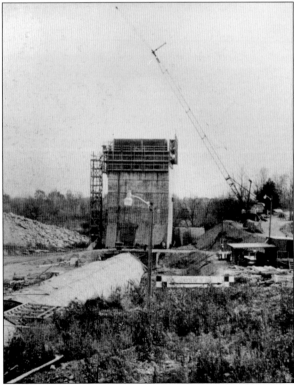

The Wabash River played a key role in the establishment and development of Huntington. However, its tendency to overflow, such as during the Great Flood of 1913, made living along the river hazardous, and farmland along the banks was often affected. To control the river, construction on the Roush Dam began in 1967. Sen. Birch Bayh (second from right) attended the ground-breaking.

Roush Dam, shown here under construction, and the lake it created were originally called the Huntington Reservoir before they were renamed in honor of J. Edward Roush, a native of Huntington who served in the US House of Representatives. Originally built by the US Army Corps of Engineers, the Indiana Division of Fish and Wildlife took over management of the recreational facilities and wildlife areas in 2010.

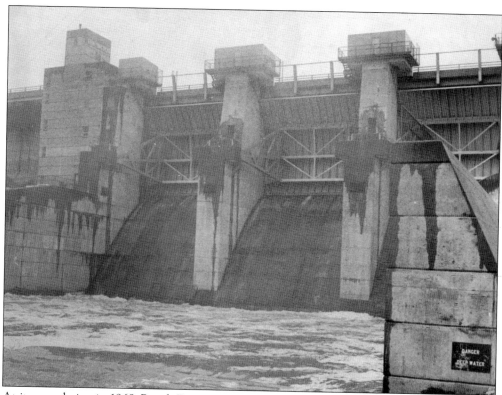

At its completion in 1968, Roush Dam was 91 feet high and 6,500 feet across, and its maximum capacity was 153,100 acre-feet. The Army Corps of Engineers continues to monitor and control lake water levels. The recreation area along approximately 15 miles of the Wabash River is 8,217 acres, including 870 acres of water. The area is a favorite spot of local hunters and fishermen.

Congressman J. Edward Roush (1920–2004) represented Indiana's fourth district in the US House of Representatives in the 1960s and 1970s. He graduated from Huntington High School in 1938 and Huntington College in 1942, served in the Army from 1942 to 1946, and graduated from the Indiana University School of Law in Bloomington in 1949. While in Congress, Roush crafted the legislation that created the 911 emergency telephone system. (Courtesy of United Brethren Historical Center.)

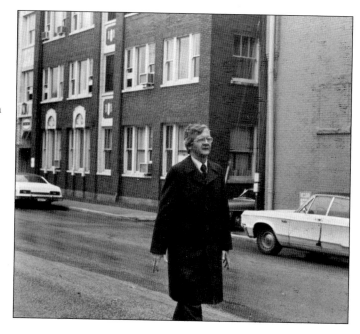

# Come, See and Hear
## SENATOR ROBERT F.
# KENNEDY
## ON
# TUES., APRIL 23, 1968
## AT 4:45 P.M.

—— at the ——

## WABASH R. R. CROSSING
### at Jefferson Street

This flyer promoted Sen. Robert F. Kennedy's stop in Huntington during his primary campaign tour through Indiana in April 1968. Kennedy's campaign for the Democratic Party nomination surged when Indiana gave him a majority in the May 7 election. He was assassinated on June 6, on the night of the California primary, six weeks and two days after his Huntington visit.

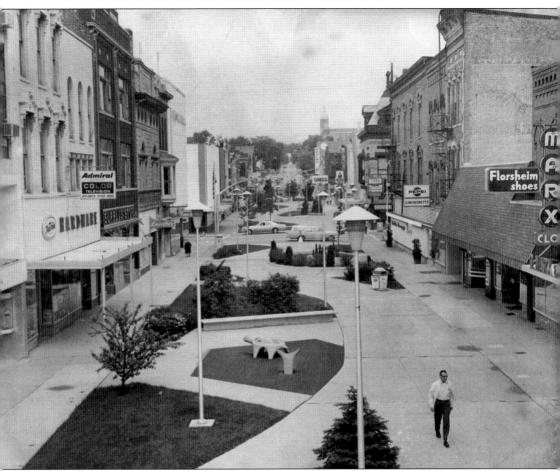

This is a full view of the Jefferson Mall in the 1960s. The pedestrian area was designed to bring in more shoppers who could walk leisurely while doing their shopping. Unfortunately, because there was little parking available, "The Mall" had the opposite effect, and with the addition of the Route 24 bypass business actually waned in the downtown area. The streets were rebuilt in the mid-1980s.

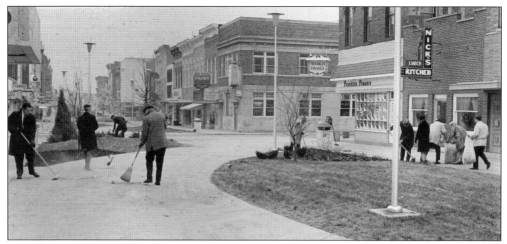

After the mid-1960s, three blocks of downtown Huntington along Jefferson Avenue were converted into a pedestrian area, referred to as "The Mall," which existed until the mid-1980s. Here, citizens of Huntington participate in a community cleanup outside of Nick's Kitchen around 1969. (Courtesy of United Brethren Historical Center.)

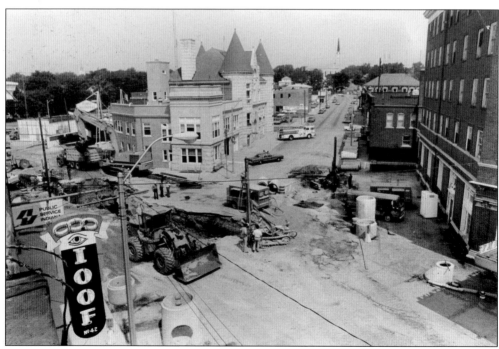

The history of public works in the area dates to the founding of the town in the 1830s. The first sewer line was located in the dry Flint Creek bed, running from the north of town into the Little River. Water mains and pumping stations came along in the 1880s and 1890s. Here, city workers improve a sewer line at State and Cherry Streets in 1978.

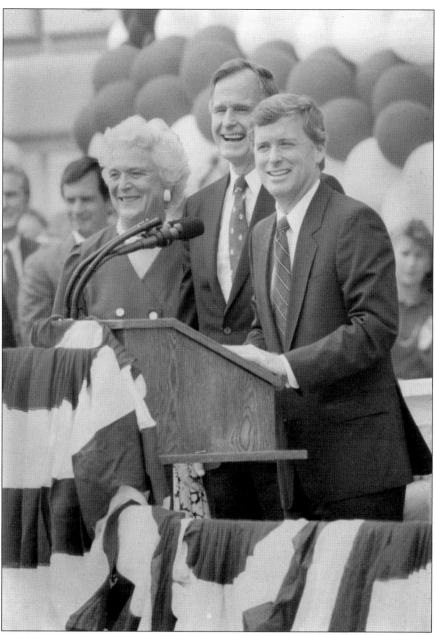

James Danforth "Dan" Quayle was born in Indianapolis in 1947. His maternal grandfather owned a dozen newspapers, including the *Arizona Republic* and the *Indianapolis Star*. Quayle grew up in Arizona, but he moved to Huntington and graduated from Huntington High School in 1965. He received degrees from DePauw University and the Indiana University McKinney School of Law before entering politics. Quayle defeated Rep. J. Edward Roush in a 1976 race for a seat in Congress. He was then elected to the Senate in 1980. He ran for the Republican Party nomination for president in 1988 but eventually withdrew in support of then Vice President George H.W. Bush. Once nominated, Bush tapped Quayle to be his running mate, and both appeared in Huntington on August 19, 1988, to make the formal announcement. (Courtesy of the Quayle Vice Presidential Learning Center.)

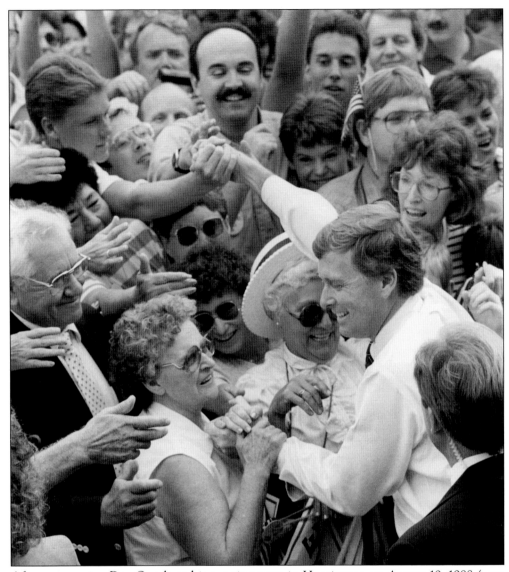

After announcing Dan Quayle as his running mate in Huntington on August 19, 1988 (seen here), George H.W. Bush won the presidency and appointed Quayle to several important posts. Vice President Quayle chaired the Council on Competitiveness and the National Space Council and represented the United States on visits to 47 different countries. After his term of office, Quayle and his family moved to Arizona. In 2000, he ran for the Republican Party nomination for president, but his campaign was short-lived, and he retired from politics. He spent much of his post-political career in private equity management, investment banking, and corporate governance. (Courtesy of the Quayle Vice Presidential Learning Center.)

# Five

# SOCIETY AND CULTURE

The departure of many Miamis in the 1840s coincided with an influx of settlers from eastern states and from Germany and Ireland who settled in Huntington County and filled town lots along the Wabash and Little Rivers. They brought their ethnic traditions and cultural institutions along with them and built social institutions that proved to be durable amid the changes that railroads, industry, and consumerism introduced into the area. Roman Catholicism appeared with French missionaries to the Miamis, and later German and Irish settlers formed congregations and eventually built Ss. Peter and Paul's and St. Mary's Churches. In the mid-19th-century, major American Protestant denominations like Methodists, United Brethren, Disciples of Christ, Presbyterians, Baptists, and Lutherans began preparations for church buildings. Over the next century, these congregations and many others contributed to the educational and charitable work of the community.

Other associations served the function of building community, collecting and distributing aid, and educating the town's young people. The United Brethren in Christ located its national headquarters in Ubee, which was later incorporated into the town's limits, and founded Central College in 1897, which was renamed Huntington College in 1961 and eventually Huntington University. The town had a McClure Working Men's Library in the 1850s and a state-authorized public library starting in 1889, which was eventually moved in 1903 to a building funded by Andrew Carnegie under his national public library building program. In the early years, Huntington was home to the United Brethren Publishing House, and in the 20th century the *Indiana Farmer's Guide* and *Our Sunday Visitor*—widely distributed publications—were printed in town. Numerous fraternal societies and social clubs like the Independent Order of Odd Fellows and Moose Lodge, along with musical groups, youth sports teams, social service organizations, and many other associations have contributed to Huntington's rich and energetic community life.

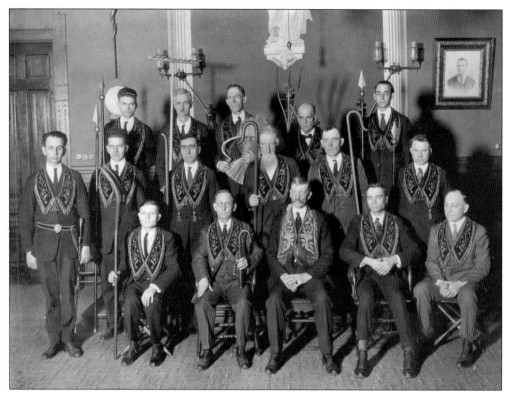

In the 19th and early 20th centuries, Huntington's residents organized numerous voluntary social and charitable associations like the Lafontaine Lodge of the Independent Order of Odd Fellows (IOOF), seen in this undated photograph. The image features the local lodge's degree team that officiated at club ceremonies where members were inducted and advanced in rank. The IOOF functioned as both a fraternal order and a benevolent society.

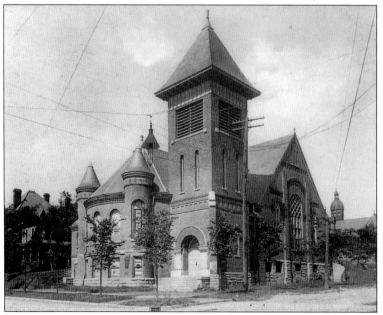

Members of the First Presbyterian Church met in the Methodist and Christian Church buildings until the building on Tipton Street, seen in this photograph, was dedicated in 1864. It was one of more than a dozen churches in town by 1860 and was active in the antislavery movement. One of its prominent 20th-century attendees was Dan Quayle.

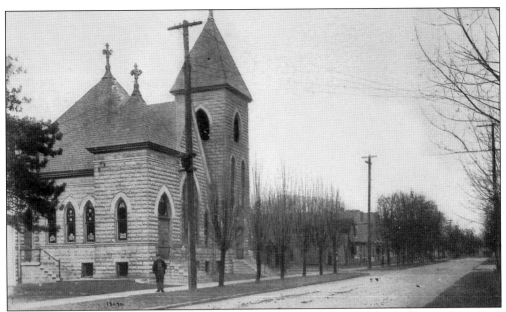

United Brethren settlers appeared in Huntington as early as 1837. The building of the First United Brethren Church is shown in this image standing on the corner of Guilford and Franklin Streets. It was completed in 1905 at a cost of $12,000. The building anchors the southwest corner of the Old Plat Historic District, which is one of six neighborhood districts listed in the National Register of Historic Places.

This image from the early 1890s shows Dr. White Cloud, an area purveyor of patent medicines. His Richmond-based operation sold proprietary drugs alleged to cure various ailments. In 1893, he conceived a scheme to promote his wares through a traveling circus, and he hired over 20 performers to take his show through Huntington, Bluffton, Marion, Logansport, and other local towns. Its failure and subsequent scandal was widely reported throughout the region.

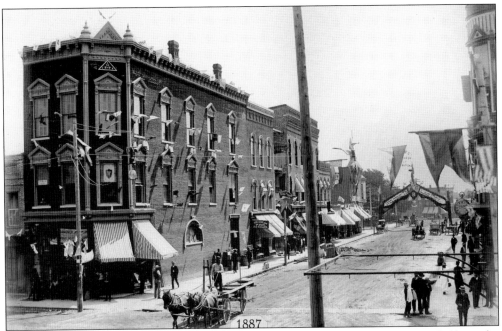

This 1887 photograph shows the prominence of Schaefer & Schaefer Drug Store (left) on the corner of Jefferson and Market Streets. The banner overarching Jefferson Street welcomes the Knights of Pythias, a fraternal order dedicated to the cause of universal peace. Begun during the Civil War, its original goal was to help "heal the wounds and allay the hatred of civil conflict."

This photograph, taken in 1909 for the Huntington city directory, shows a typical middle-class parlor of the time. The home in the photograph was located at 622 West Matilda Street (now Park Drive). In the lower right is E.A. Barnhisel, the bookkeeper for the First National Bank.

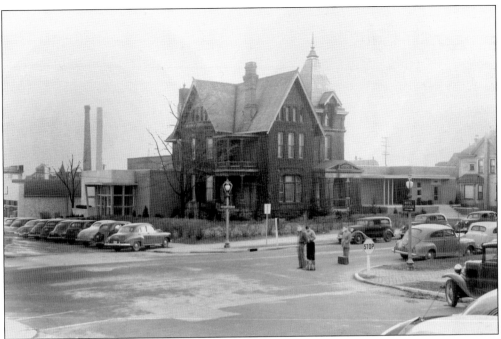

Originally a social club, by 1900 the Loyal Order of Moose had become a service organization. Mooseheart, established in 1912, was developed to care for the children of members; in 1922, the order started Moosehaven for its retired members. The Huntington chapter was founded in 1911. The lodge, shown here in 1948, was located on West Park Drive but was relocated to Frontage Road in 1973.

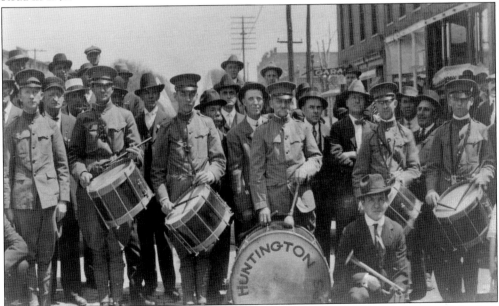

In 1917, Huntington residents responded when the United States entered World War I. Members of the Huntington County Drum Corps are seen here at a public patriotic observance in 1918. Military bands formed only one part of a local culture in Huntington that included church choirs, school marching bands, university orchestras, and live theatre.

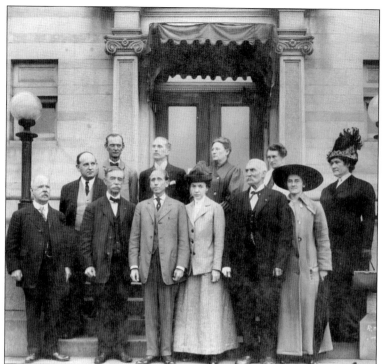

The 1911 Huntington City Library Board, including librarian Winifred Ticer (first row, center), contributed to efforts to develop what is now a strong lending library that also houses the renowned Indiana Room, a trove of Hoosier information and memorabilia. The original building, erected in 1903, was funded by Andrew Carnegie. A new building was established in 1987 on West Market Street and then expanded in 2010.

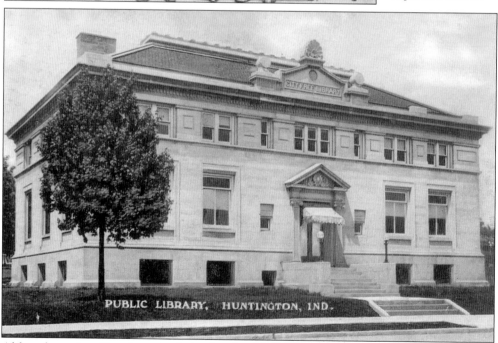

Although previous libraries existed, the first free library in Huntington was established in 1889. As it was tax supported, local citizens applied for one of the grants offered by Andrew Carnegie, who provided various communities the funds needed to build over 2,500 libraries. Carnegie gave Huntington $25,000 to build a library, which was completed in 1903 on the corner of Warren and Park Streets.

Having taught himself how to fly at the age of 15, Russell Hosler later received his aviator's license from Orville Wright in 1930. Known as Huntington's "bird boy," Hosler drew crowds as early as 1923, when he landed his OX5 Curtiss Jenny in Allen County. During Prohibition, though, he had a run-in with the law and was charged with smuggling rum between Toledo and the Canadian border.

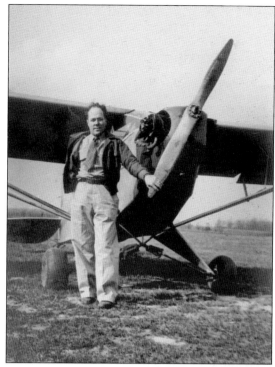

Despite being charged as a rumrunner, Russell Hosler went on to have an illustrious career in aviation, helping test the B-29s that later bombed Japan to end World War II. His specialty was working on wing construction, and as early as 1929 he had designed a plane that could reach speeds of 192 miles per hour.

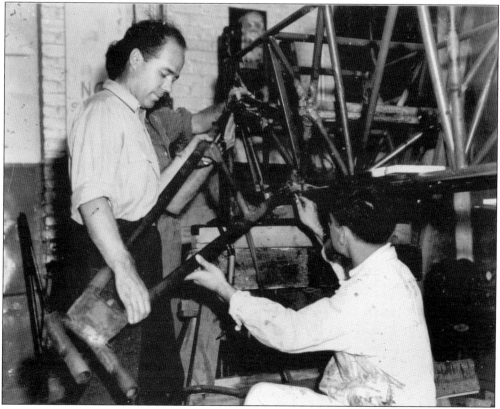

Victory Noll, home of Our Lady of Victory Missionary Sisters, occupies a prominent location on the bluff overlooking West Park Drive. The Roman Catholic religious community was created by Fr. John Joseph Sigstein in 1922 after a visit to the southwestern United States. The community focused on ministry among Native Americans in New Mexico in its early years. The community received assistance from Archbishop John Francis Noll and Our Sunday Visitor to build a home campus in Huntington, and the facility opened in 1925. Because of its connection to the Southwest, several of the buildings are designed in the Mission style of architecture. In this photograph, two Bolivian missionaries, Sr. Evelyn Mourey (left) and Sr. Diana Gutierez (center), visit with Sr. Jeanette Halbach, who was president of Victory Noll when this picture was taken in 1981.

Dedicated in 1929 on land offered by Bishop Noll, St. Felix was originally a Capuchin monastery built to allow Franciscan friars to pursue their work assisting the poor and unfortunate. After the friary shut down in 1979, the building was home to Good Shepherd United Brethren Church, as shown here. In 2010, the friary returned to Catholic hands, and it is now St. Felix Catholic Center. One of the friary's significant early occupants was the Venerable Solanus Casey. Father Solanus was sent to Huntington to rest in his later years, but he received as many as 200 letters a day, all of which he tried to answer. Noted as a man of great faith, Father Solanus has many miracles attributed to him, particularly reports of healings.

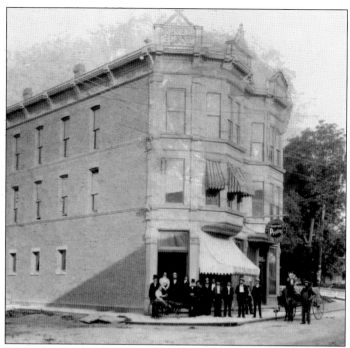

Initially founded in 1834 to publish denominational periodicals, the United Brethren Publishing House was split in 1889 after a division among the United Brethren in Christ (UB) churches. Both the New Constitution and Old Constitution UB churches continued their own publications in Dayton until the Old Constitution UB church moved its operations to Huntington in 1897. The original building, shown here in 1900, was on the corner of Riverside and Jefferson Streets.

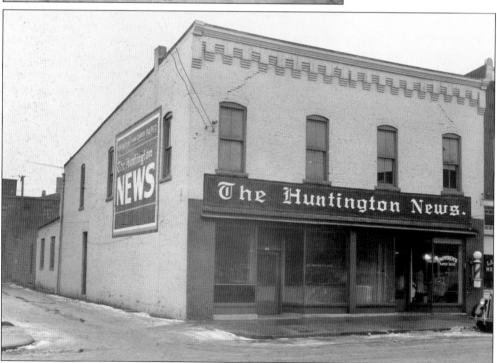

Huntington's first newspaper, the *Indiana Herald*, appeared in 1848. Several other newspapers, including the *Lime City News* (1878), began soon after. The *Lime City News* merged with the *Andrews Express*, and in 1887 the *News-Express* consolidated with the *Indiana Herald* to form the *Huntington Herald*. Further consolidations carried management of the *Herald* out of the city, enabling upstarts like the *Huntington News*, pictured here, to claim to be "home-owned."

The interior of the *Farmer's Guide* office is seen here in 1941. The *Farmer's Guide* began publishing in Huntington in 1889 as the *Breeder's Guide* under the leadership of its founder, B.F. Billiter. It enjoyed a regional reputation as a resource for American farmers during a period of transition in agricultural science, resource conservation, and mechanization. In 1901, its circulation stood at 26,000, and it continued publication into the 1960s.

The *Farmer's Guide* printing press is shown in this 1941 photograph. It was located just west of the City Building on Market Street. In 1917, the *Farmer's Guide* took control of the *Indiana Farmer* and merged its two publications into the *Indiana Farmer's Guide*, thereby increasing its circulation to 140,000. Along with the *Guide*, it published material like the *Everson Farm Manual* and cookbooks.

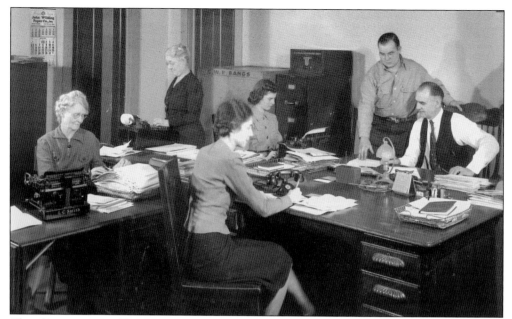

Clare Bangs came to Huntington in 1912 as a member of the Central College (now Huntington University) faculty. He became president of the college at age 25, serving from 1915 to 1919. As well as serving as mayor, Bangs (seated, far right) owned and published the *Huntington News* with the help of his wife, Nellie (standing in the background), who had also served on the faculty of Central College. Lake Clare is named for him.

Huntington mayor Clare Bangs (right) is greeted by Clayton Brown as he leaves the jail where he had been held for several months in 1937. Bangs, who served as mayor from 1935 to 1939, was being held for contempt because he allowed the municipal power plant to serve customers previously served by the Northern Indiana Power Company. He had to conduct city business from his jail cell.

These women in the early days of Our Sunday Visitor are preparing one of its publications for distribution. Founded by Fr. John Noll in 1912 with a printing press he purchased for $1, Our Sunday Visitor has become one of the largest Catholic publishing houses in the world. Father Noll, later the bishop of Fort Wayne and then the archbishop, started the original *Our Sunday Visitor* newspaper to counter anti-Catholic sentiment.

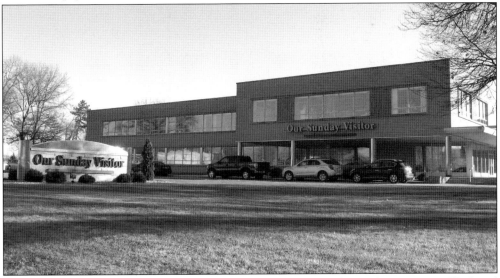

The early Our Sunday Visitor building was constructed in 1926 on the southwest corner of Park and Warren Streets. The current location, shown here, was dedicated in 1960 and continues its mission: "To serve the Church." Our Sunday Visitor was selected by the Vatican to distribute the North American English edition of the official Vatican newspaper, *L'Osservatore Romano*, and it continues to publish numerous Catholic periodicals, books, pamphlets, and catechetical materials.

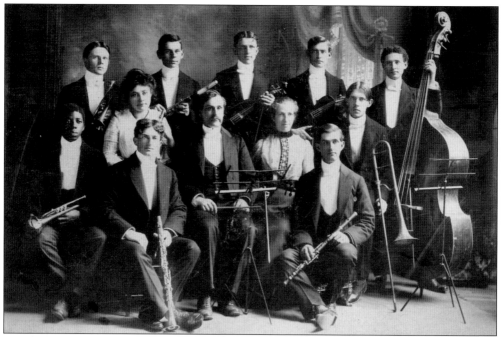

The 1901–1902 Central College (now Huntington University) orchestra included Fred Loew (first row, right), who later became a professor of biology and agriculture at the college and helped establish the Huntington College Foundation to connect university and local business leaders. Christopher Wilberforce (second row, far left) returned to his father's homeland, Sierra Leone, to serve on the mission field for the United Brethren in Christ Church. (Courtesy of United Brethren Historical Center.)

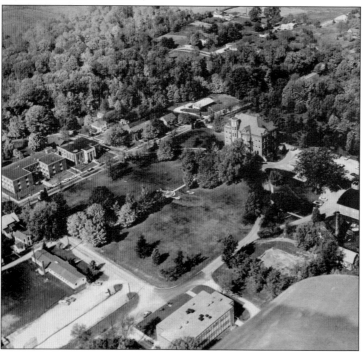

Founded as Central College in 1897 with the help of the Huntington Land Association, the original brick structure (center) now stands as the centerpiece of Huntington University. The building's spire was removed in 1953 due to structural decay and is absent in this photograph from around 1965. It was later restored through the efforts of interim president J. Edward Roush. (Courtesy of United Brethren Historical Center.)

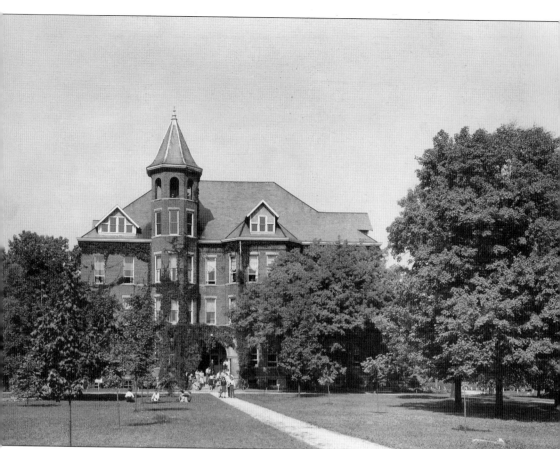

The United Brethren in Christ has a rich history of providing Christian higher education. While many of the colleges it founded were lost in an early denominational split and others closed, Huntington University, the only remaining denominational college, stands as a paragon of its commitment to educating men and women. Bishop Milton Wright, the father of the famous flying brothers Orville and Wilbur Wright, helped oversee the construction of what is now Becker Hall, pictured here in the 1940s. Opening in 1897 with seven faculty members and 85 students, the college almost closed in the 1930s due to financial difficulty. However, after the board restructured the administration, the dedicated faculty achieved full accreditation by the national accrediting agency in the late 1950s. A vibrant community, Huntington University continues to provide a Christ-centered liberal arts education to its students. (Courtesy of United Brethren Historical Center.)

Steve Platt is Indiana's all-time leading scorer in college basketball with 3,700 career points. Platt graduated from Union Township High School in 1965 and played at Huntington College from 1970 to 1974, where he averaged 33 points per game over a 112-game career. Platt coached at his alma mater for 14 years and was inducted into the Indiana Basketball Hall of Fame in 1996. (Courtesy of United Brethren Historical Center.)

Organized in 1897, the College Park United Brethren congregation began meeting at Central College (now Huntington University) before moving to a public school building. When the public school closed, the church purchased and remodeled it, dedicating it in 1930. Although College Park Church has undergone numerous expansions, the original structure can still be discerned. The church continues to serve as a partner with Huntington University. (Photograph by Jeffrey Webb.)

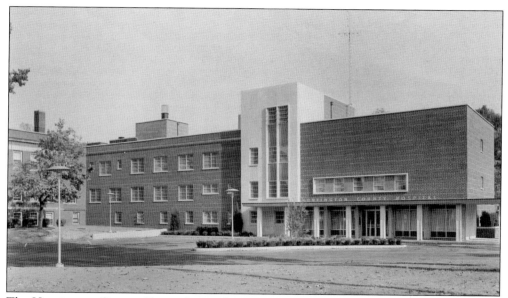

The Huntington County Hospital, seen here around 1962, opened on Etna Avenue in 1917. Additions were added in 1943 and 1960. As the county population grew and the medical field expanded, the hospital added a wide variety of medical services, including cardiac care and oncology. In 2000, the community welcomed Parkview Health and its $16.4 million modern medical complex, which replaced the old Huntington County Hospital. (Courtesy of United Brethren Historical Center.)

Medical care in Huntington County traces its history back to the 19th century. In 1902, county health officer Dr. Charles L. Wright converted a hotel into a quarantine facility, which eventually became a permanent hospital. A nurse's training school began operations as early as 1907. In this photograph, nurses enjoy a break from work at Huntington County Hospital in 1962. (Courtesy of United Brethren Historical Center.)

A Huntington favorite since 1960, the Hoosier Drive-In holds fond memories for many locals. If it can be fried, the Hoosier Drive-In probably serves it: hand-cut fries, breaded cheeseburgers (the burger is breaded and then deep fried), fried pickles, and even fried Twinkies are all on the menu. While it can sometimes get crowded, loyal customers know that it is worth the wait. (Photograph by Jeffrey Webb.)

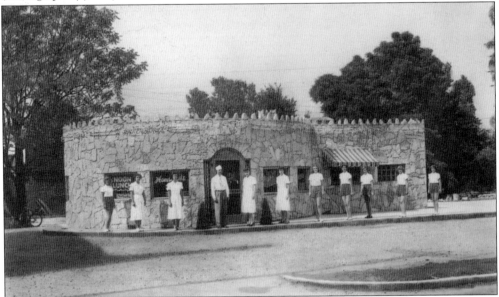

The castle-like appearance of Johnny's has made it an icon in Huntington, and the tasty burgers and "delicious cinnamon rolls" keep both regulars and first-timers happy. John "Johnny" Davis designed the restaurant based on a castle he saw flying into Clark Air Field in the Philippines, where he was stationed during World War II. His matchboxes read, "Get a square meal in a round building." (Courtesy of Monte Davis.)

Johnny's Drive-In was the place to be. Customers came from all over for his homemade milkshakes. At one time, Johnny's was Sealtest's single largest customer. Wanting the best for his customers, Johnny, shown here in the 1950s, would wake up at 4:00 a.m. to get fresh buns from the local bakery. Today, Johnny's son Monte continues the tradition of putting the customer first. (Courtesy of Monte Davis.)

The Huntington Drive-In, at 1291 Condit Street, began operations in 1950. Expanding middle-class automobile ownership and the golden age of Hollywood drove the construction of drive-in theaters in the 1940s and 1950s. In 1948, there were 820 nationwide; 10 years later, there were 4,063. The drive-in became an important part of social life for Huntington families and teenagers in the postwar era. (Photograph by Jeffrey Webb.)

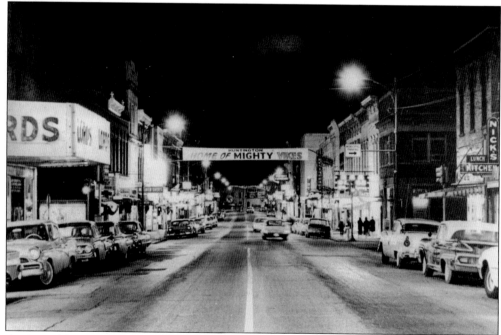

A sign in downtown Huntington expresses pride in the Huntington High School Vikings in this photograph from the early 1960s. From 1961 to 1964, the boys' basketball team won four sectional and regional championships. The squad also played for the state championship in 1964, losing to Lafayette Jefferson by a score of 58-55. In 1966, the county schools were reorganized, and the local high schools were consolidated into Huntington North High School.

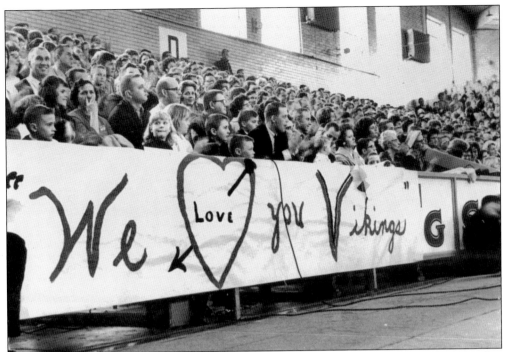

The Huntington High School boys' basketball team was the runner-up in the 1964 championship game, and the community rallied in support, as pictured here. The team defeated unbeaten Columbus North in the semifinal to reach the final game and finished the season at 27-2. Team leader Mike Weaver went on to play at Northwestern University and was enshrined in the Indiana Basketball Hall of Fame. He later became president of Weaver Popcorn.

In this photograph from 1964, Camile Kaylor and John Fouts pass through a heart-shaped arch at the "Sweetheart Dance" at Huntington High School. The high school served as a focal point of community life in the 20th century. After consolidation in 1966, Huntington North High School (HNHS) was built on MacGahan and Jefferson Streets. It opened in 1971. In 2010, the enrollment for HNHS was 1,993 students.

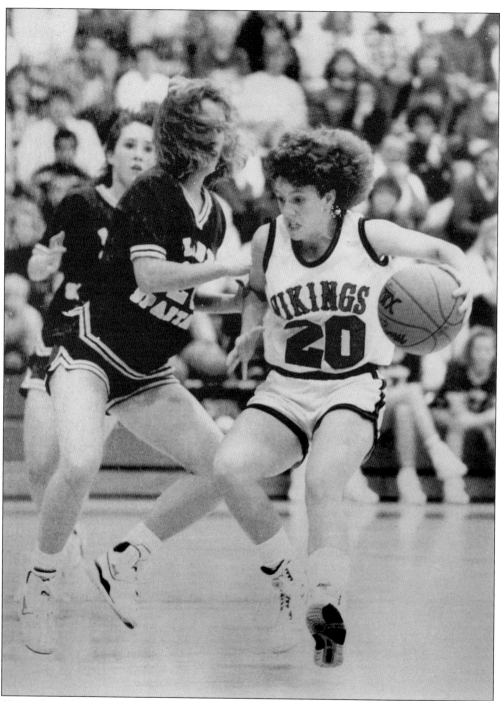

Shown here driving to the basket, Marcy Hiner was a member of the 1990 Huntington North High School state championship girls' basketball team. Fred Fields, the winning coach, also led the team to a state championship victory in 1995 as well as three other state finals appearances, six regional championships, and 10 sectional championships in his 10 years as head coach.

In the 21st century, Huntington confronts the same challenges as other towns in Middle America. It has risen to these challenges with efforts like the Huntington County United Economic Development Corporation, which works with businesses and industries to expand operations in the region. These efforts have successfully preserved thousands of jobs in a time of downsizing, outsourcing, and automation in American manufacturing. Key industries like United Technologies, ALH Building Systems, Continental Structural Plastics, and Ecolab provide employment for area residents. Huntington's educational institutions, including the Huntington County Community School Corporation and Huntington University, are engaged in innovative programs to help prepare young people for careers in a dynamic, changing economy. In a time of transition, Huntington's leaders and its people remain committed to preserving a vital community spirit.

# BIBLIOGRAPHY

Bash, Frank Sumner. *History of Huntington County Indiana*. Vol. 2. Chicago and New York: The Lewis Publishing Company, 1914.

*Biographical Memoirs of Huntington County, Indiana*. Chicago: B.F. Bowen, 1901.

Chambers, Doris M. *Up from Stubble: A Saga of College Park Ubee, Indiana*. Huntington, IN: Hill Crest Lithographing, 1973.

Diffenbaugh, Robert, Joan Keefer, and George Bachnivsky, eds. *Historic Pictures of Huntington County*. Huntington, IN: Advanced Creative Enterprises, 1988.

Fetters, Paul, ed. *Trials and Triumphs: A History of the Church of the United Brethren in Christ*. Huntington, IN: Church of the United Brethren in Christ Department of Church Services, 1984.

*History of Huntington County, Indiana: From the Earliest Times to the Present*. Chicago: Brant and Fuller, 1887.

Huntington County Historical Society. *Huntington County, Indiana: History and Families, 1834–1993*. Paducah, KY: Turner Publishing Company, 1993.

"Huntington County Interim Report." Second Edition. Indiana Historic Sites and Structures Inventory. Indianapolis: Indiana Department of Natural Resources, 1997.

# About the Huntington County Historical Museum

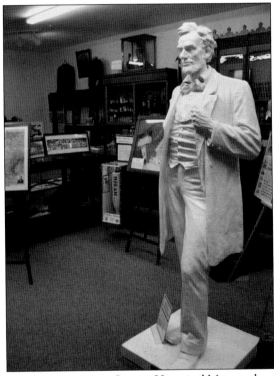

Incorporated in the 1920s, the Huntington County Historical Museum has been one of the largest county conservers of Huntington history for the past 90 years. Its goal is to collect, preserve, interpret, and promote interest in the history of the community. The museum is committed to seeking the widest possible involvement of people interested in the history of Huntington County and its mission.

The museum holds thousands of artifacts that pertain to the history of the county and the surrounding region. Visitors will find a vast display of Native American relics and Civil War heroes, a restored mural from the beautiful Hotel LaFontaine, and a model of Huntington from around 1835, as well as a handmade display of the city's Erie rail yard. The museum also holds hundreds of images and documents from hundreds of businesses and families; it is an excellent research center.

The museum furthers education by establishing cooperative educational programs with local public and parochial schools, and it hosts bimonthly meetings that share history with the general public.

The museum is located in downtown Huntington at 315 Court Street. Please visit Wednesday through Friday from 10:00 a.m. to 4:00 p.m. and Saturdays from 1:00 p.m. to 4:00 p.m. or visit the website at www.huntingtonhistoricalmuseum.com.

# DISCOVER THOUSANDS OF LOCAL HISTORY BOOKS FEATURING MILLIONS OF VINTAGE IMAGES

Arcadia Publishing, the leading local history publisher in the United States, is committed to making history accessible and meaningful through publishing books that celebrate and preserve the heritage of America's people and places.

Find more books like this at
**www.arcadiapublishing.com**

Search for your hometown history, your old stomping grounds, and even your favorite sports team.